PETERSFIELD
AT WORK

DAVID JEFFERY

AMBERLEY

First published 2017

Amberley Publishing
The Hill, Stroud
Gloucestershire, GL5 4EP

www.amberley-books.com

Copyright © David Jeffery, 2017

The right of David Jeffery to be identified as the
Author of this work has been asserted in accordance
with the Copyrights, Designs and Patents Act 1988.

ISBN 978 1 4456 7260 1 (print)
ISBN 978 1 4456 7261 8 (ebook)

British Library Cataloguing in Publication Data.
A catalogue record for this book is available
from the British Library.

Origination by Amberley Publishing.
Printed in the UK.

CONTENTS

INTRODUCTION

From the earliest times, the Hampshire market town of Petersfield has enjoyed its favourable position nestling in the South Downs at an important junction for trade and industry. Its charter, dating from 1181, stipulated that the new town developing in the north of the manor of Mapledurham (now in East Hampshire) was entitled to hold fairs and create merchants' guilds under the same conditions as those enjoyed by the inhabitants of Winchester. A marketplace and burgage plots, set out on either side of the main street to provide housing and space for a workshop or garden, grew up around the newly founded St Peter's Church from which the town derived its name.

In the Middle Ages, sheep and cattle farmers brought their livestock to market here and Petersfield served as the hub for the sale and purchase of farm stock for all the local villages. Farmers, shepherds, drovers, tanners, spinners and weavers were all centred around the town's burgeoning farming and woollen industries.

In the eighteenth and early nineteenth centuries, mail coaches used Petersfield as a stopping point on their north–south route from London to Portsmouth, or from the east–west trackways, which the Romans had used to link Chichester and Silchester with Winchester. The hospitality industry was born: inns flourished and multiplied, and accommodation became ever more sophisticated. Both innkeepers and coach passengers benefited from the attentions of ostlers, farriers, liverymen, butlers, cooks and sundry other staff.

In the mid-nineteenth century, it was the arrival of the railway that was to ensure the forthcoming prosperity of the town: it brought new jobs in the construction industry; family firms set up businesses that were to last for several generations (and which still exist today); a new enterprise culture was established within the town catering particularly for middle-class customers; and the working classes found employment in a variety of new trades. The brewhouses took on apprentices, the new Corn Exchange needed auctioneers to buy and sell goods, and individual shops required assistants, delivery boys and backroom assistants.

The twentieth century saw the real shift in employment opportunities: from what had once been a predominantly agricultural community, Petersfield was transforming into a more commercially varied and outward-looking society. Its population, which had doubled in the Victorian era, now grew at a rate of around 1,000 residents every decade.

At the turn of the twentieth century, the erstwhile ruling lords of the manor lost their influence on the town's affairs and businesspeople took on the responsibilities of local government.

In more recent times, the town has witnessed a further shift in direction. With the demise of its ancient cattle market and the trades associated with the traffic of animals, a newly emerging sector of the economy has been the emphasis on, and creation of, business and industrial work in its Bedford Road industrial estate and the Petersfield Business Park on the town's outskirts. The town's bypass and the more recent opening of the Hindhead Tunnel on the A3 has ensured that, with such improved communication, firms can now operate from Petersfield across the whole of the south of England and, in many cases, far wider still.

This volume traces the successful economic story of the town and features some of the private and public, local and national, individual and corporate companies that have chosen Petersfield as their base.

Petersfield's town flag.

THE BRONZE AGE AND IRON AGE

The earliest traces of human settlement in Petersfield have recently been excavated and documented under the project title of 'People of the Heath'. These finds – below the impressive early Bronze Age barrows on Petersfield Heath – date back to around 5,000 BC, when the area was probably heavily wooded and the first inhabitants were hunter-gatherers living mainly in river valleys.

The valley is that of the River Rother, which flows west to east and whose small tributaries pass through the town. The underlying chalk of the Downs is superimposed here with greensand, thus providing a well-drained landscape for agricultural use, although the quality may vary from fertile to fairly sterile.

Ancient trackways point to a visible conjunction of a north–south axis through the Downs to the south of Petersfield and an east–west axis along the Rother Valley, which ensured ease of access for nomadic tribes and their animals. Equally, the nearby forests provided shelter, materials and hunting grounds for human survival. Water filtering from streams emerging from the subterranean chalk would have provided clean drinking and cooking water, along with fish to eat. Our ancestors would have foraged for berries growing on the Downs, supplying both food and medicine for the population; the forests would have provided game, but some of them would have been cleared for farmers to graze their cattle. Evidence has shown that there were sophisticated field systems here 3,000 years ago.

It is also clear from recent discoveries that there was a substantial amount of domestic and commercial activity in this area and that the dead of these communities were buried around the Heath. The presence of both flint blades and bronze dagger blades under the prehistoric barrows suggest commercial occupations such as flint-knapping, woodworking and the processing of hides. Flint meant wealth, and flints from the South Downs have been found as far away as East Anglia. Trade between the different Mesolithic communities in the area – notably at nearby Froxfield – would not only have been commonplace but also vitally necessary to their survival.

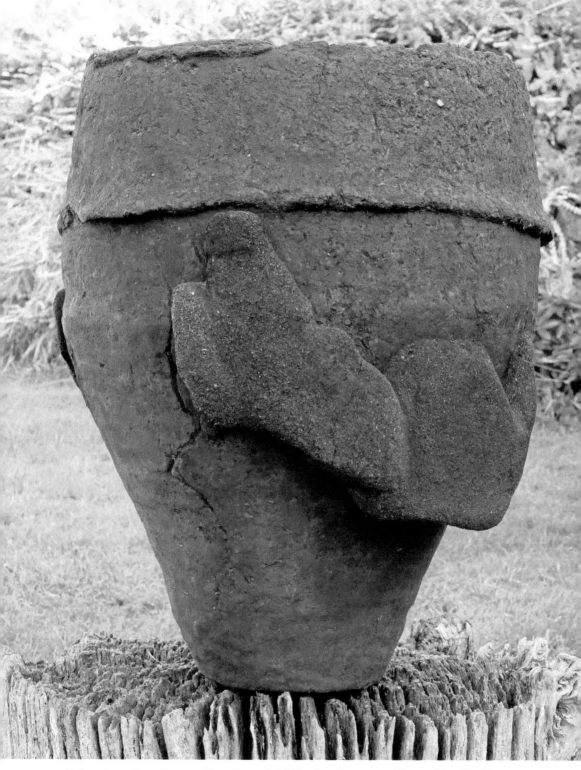

Collared urn from Barrow 8 on Petersfield Heath. (Courtesy of Stuart Needham)

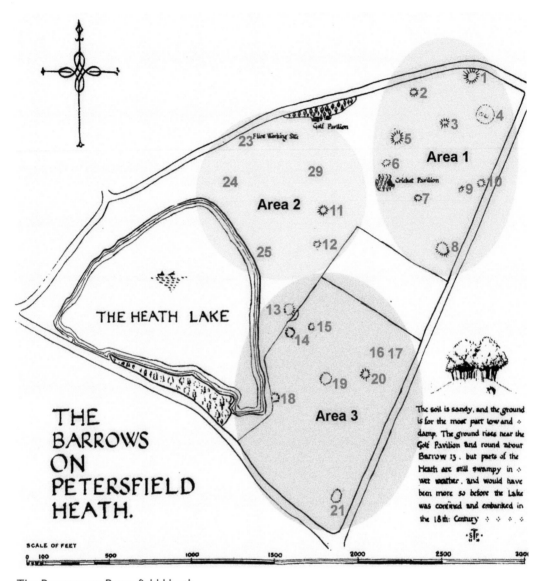

The Barrows on Petersfield Heath.

Sheep on the South Downs.

THE ROMAN, SAXON AND MEDIEVAL PERIODS

The Petersfield area became the home of many Roman communities; the villages that we now know as Froxfield, Stroud, Buriton, Langrish, Colemore and Liss all housed Roman families, and these were commercially orientated groups. Little evidence can be seen of military activity, which suggests a harmonious relationship with the indigenous population, one based on a reciprocal acceptance of living conditions, ideas, governance and trade. Many tribes in the south of England, for example, had adopted a 'Romanised' lifestyle: they drank wine instead of Celtic beer, used Roman coinage and, most importantly, worshipped Roman gods. It was the Romans who introduced brown hares and pheasants to the local diet. William the Conqueror declared parts of the Downs as royal hunting grounds for the Norman kings, and it was this hierarchy that survived beyond the Roman presence when their royal territories became the properties of future lords of the manor.

The original late Iron Age round wooden huts were slowly replaced with rectangular stone buildings. This indicates both a growth in population and an extension of commercial and industrial outlets, in particular, the associated skills and trades needed for such developments – stonework, brickwork, tilework, road building and a variety of new crafts to sustain such advances.

Petersfield's position on the junction of both east–west and north–south axes guaranteed that the town became a focal point for movement between London and the Roman towns of Portchester, Winchester, Silchester and Chichester. The earlier nomadic existence of pre-Roman tribes had given way to a more static concentration of families and commercial groupings. Roman strongholds were sited across the Downs, particularly on the routes to London.

Although the earliest traces of a substantial human settlement on Petersfield Heath date back to the twenty-one early Bronze Age barrows, the town proper dates from the twelfth century, when it formed part of the large royal manor of Mapledurham, centred on what is today the nearby village of Buriton.

The Domesday Book of the late eleventh century recorded that this estate was owned first by William the Conqueror, and then by his widow Matilda after his death in 1087. William's great-grandson, Robert, Earl of Gloucester, later founded a borough in the northern part of the manor where there was a small chapel dedicated to St Peter, a marketplace, and burgage plots. It was this new borough, separated from Mapledurham by swamps and marshes, which became Petersfield.

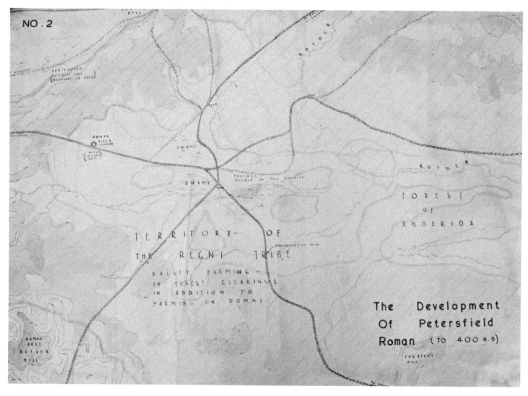

Petersfield in Roman times. (Petersfield Museum)

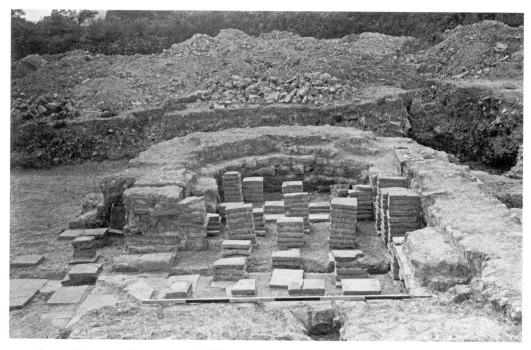

Stroud Roman villa, excavated 1908.

Signpost for Petersfield on the A3.

The most known – and extant – document recording the foundation of the town was the charter signed by Hawisa, Earl Robert's daughter-in-law in 1184, which reiterated the terms of a previous charter, whereby Petersfield was permitted to function as a commercial centre in exactly the same way as Winchester could. The charter emphasised the rights of its citizens to hold markets and to form trading guilds, thus ensuring Petersfield's future prosperity.

It was during this same period that the identity and importance of the town was consolidated with the building of a new church dedicated to St Peter, ostensibly a chapel of ease serving the northern parishioners of Mapledurham, but in fact emerging as the cornerstone of the new town and its development along commercial lines. The church was constructed in the very centre of the town, with a square alongside where merchants gathered to sell their wares.

The principal means of income for Petersfield residents would have been linked to sheep – which probably outnumbered the human population by around three to one. The Downs were their habitat, and Petersfield supplied their farmers, drovers, slaughterers and salesmen. During the Middle Ages associated industries provided work for the wool and leather trades, along with specialist workers for tanning, fulling, carding, spinning and glove-making. Petersfield itself produced a coarse-ribbed cloth called kersey, which was sent for sale in London.

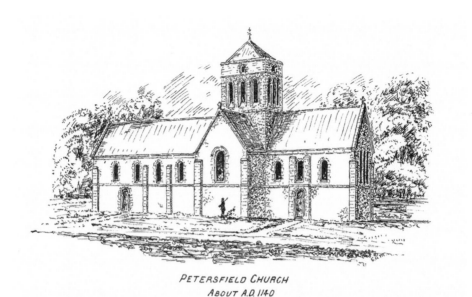

St Peter's Church, c.1140. (E. Arden Minty)

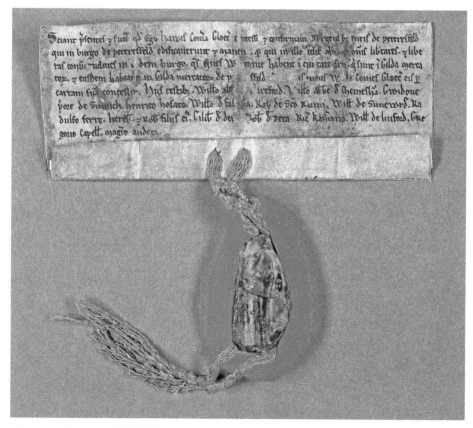

The town charter of 1184. (Hampshire Record Office)

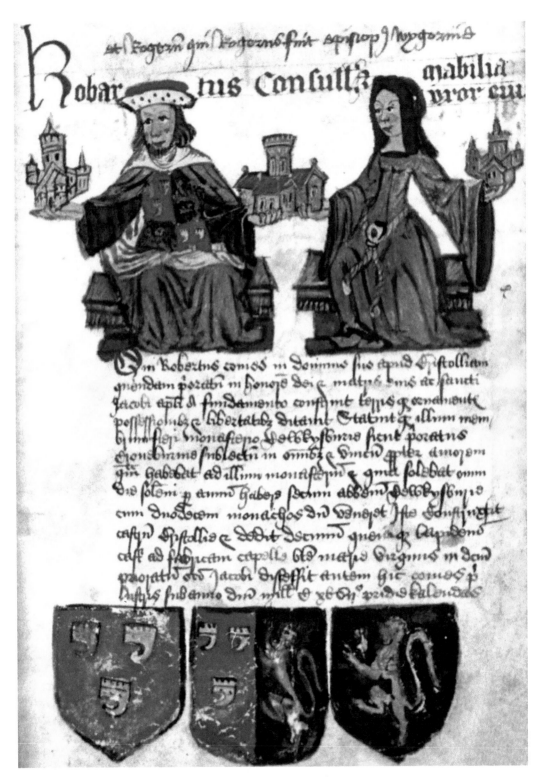

Robert, Earl of Gloucester, founder of the town in the twelfth century.

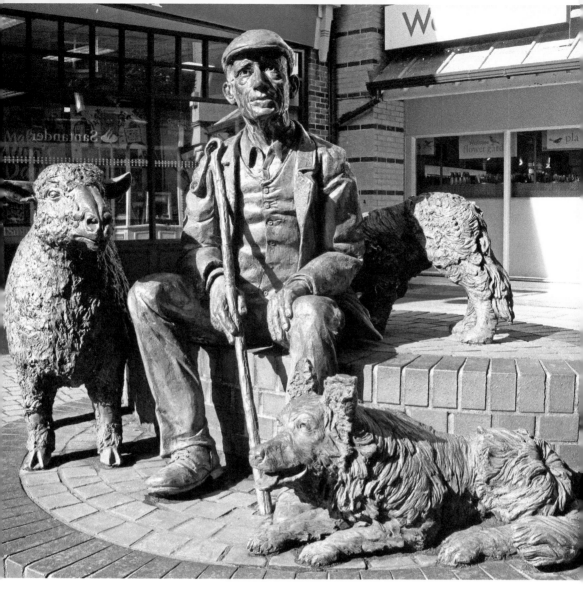

Andrew Cheese's sculpture of the Downsman, 1999.

THE TUDORS AND STUARTS

At the beginning of the sixteenth century, Hampshire had between 40,000 and 50,000 inhabitants. It was a green and peaceful agricultural county in which miles of deep forest alternated with 1,000-acre fields of barley, beans or wheat, or with variegated heaths and bleak moors and small-scale pastures. The economy was still weak, with too few people to civilise the whole landscape, too few to develop the rich mineral resources, and too few to develop any large-scale industry.

The chalk and limestone downlands still resembled the open and rolling sheep pastures of the eight century. However, although the trades associated with sheep-rearing still dominated the local economy throughout the span of the South Downs, the discovery of iron in the eastern section of the area led to the production of probably the best iron in the country. It was an industry that was to last for well over 200 years, and which produced the iron that made cannons for the seventeenth-century Navy.

During the fifteenth century, the creation of hundreds of little market towns – each serving an area within a radius of 3–5 miles – had brought into existence for the first time a great number of roads, joining town to town. Petersfield's own charter ensured that it was prominent within this new network and its economic importance therefore contributed extensively to further social and economic advances. However, it was not a large town: it is estimated that there were around 100 dwellings, suggesting a total population of approximately 600. This was hardly more than twice the size of nearby villages.

The most significant and lasting effect brought by the road network was the rapid development of coach travel during the second half of the seventeenth century. Not only did this presage the expansion of the inn trade, but it undoubtedly brought prosperity to Petersfield, providing countless jobs to local people for at least half a century. At its peak in the early eighteenth century, the twenty-eight coaching routes running through the town from London to Portsmouth required many coachmen and stablemen and coaching was probably the greatest supplier of work for its inhabitants.

Although the Romans had ensured that roads were built and maintained for around 400 years until their departure in AD 410, little was done thereafter to guarantee the free passage of all manner of horse, pack mule and donkey traffic along the highways and byways until the twelfth century. Sadly, during the Middle Ages, travellers were looked upon as unfortunate individuals deserving of pity and the repair of roads had to be a carried out by

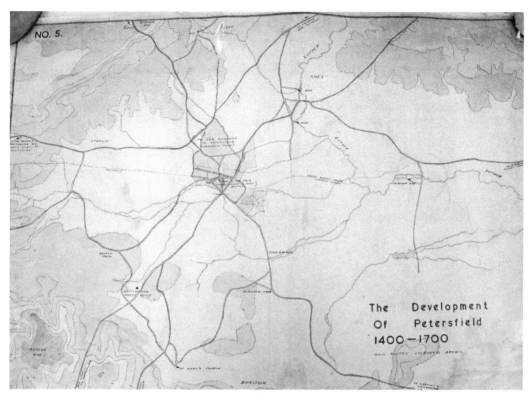

The development of Petersfield, 1400–1700. (Petersfield Museum)

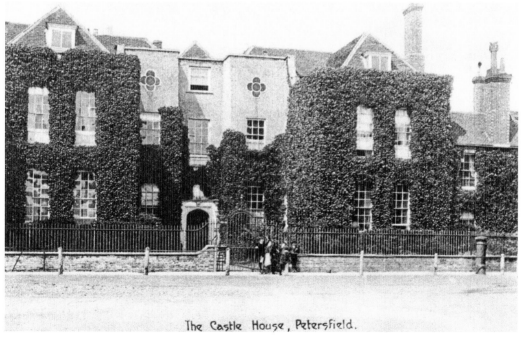

Castle House, late sixteenth century.

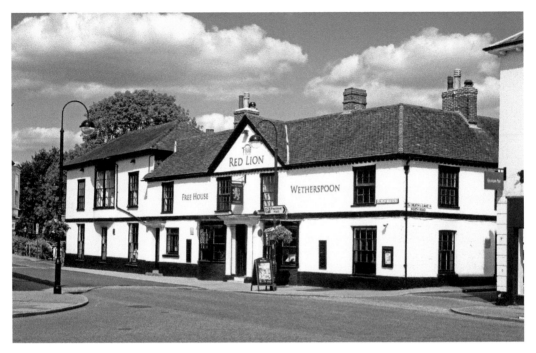

The Red Lion today.

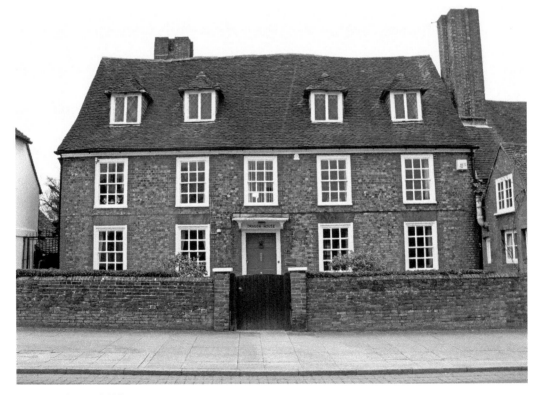

Dragon House, 1625.

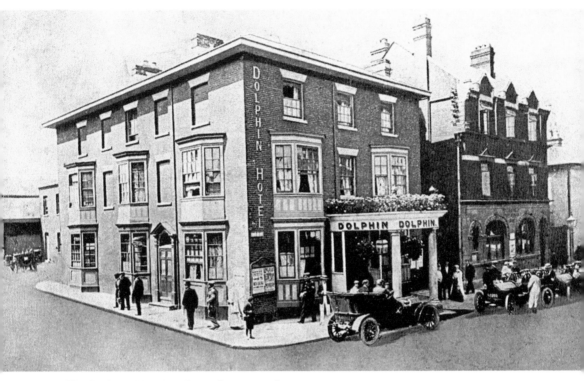

The Dolphin Hotel in the early twentieth century.

private landowners or the parishes. As a result, high roads were full of holes and bogs, making travel extremely uncomfortable and even dangerous.

The first generation of carriages was seen in the Tudor period, though these were almost exclusively reserved for female passengers. Journeys were, moreover, extremely tedious and carriage design did not allow a great deal of comfort to travellers along the major roads. Even half a century later, by the time Samuel Pepys was writing his diary about his journeys throughout the kingdom in 1662, it took him and his companions seven hours to travel from London to Petersfield.

To illustrate the near impossibility of travelling from town to town in this period, we can refer to either Pepys or Daniel Defoe, who, even in the early eighteenth century, described rural Surrey and Hampshire as 'a vast tract of land [where] the soil is not only poor, it is even quite sterile, given up to barrenness, horrid and frightful in appearance, not only good for little, but good for nothing. The product of it feeds no creatures but some very small sheep.' It is tempting to brush aside such disparagement as a London-centric, upper-class view of the local countryside, but it is also clear that to eke out a living in Petersfield without mineral resources, rich agricultural land or an established industry was a challenge. It might be concluded, therefore, that the town saw its opportunity in its geographical location on the London–Portsmouth road to exploit the needs of wealthy travellers as a means of survival and that this initiative brought about some commercial enterprise among its citizens.

In the first part of the seventeenth century, Portsmouth's increasingly important role as the country's major naval base also drew Petersfield into greater prominence. Many of its young men would have enlisted in the Navy and others would have found employment in the dockyards; yet some would find Petersfield an ideal stopping place en route to Portsmouth,

or even Southampton, which boasted carrier services linking them to London. Trade with the dockyards ensured Petersfield's own commercial importance, since timber, navy supplies and workers went through the town from both directions between London and Portsmouth.

At this time, Petersfield High Street boasted four major inns to accommodate this trade: the White Hart, the Crown, the Anchor and the Angel (later The Half Moon). None of these still exist, but it is obvious from their position in the middle of the High Street that they drew visitors to the very heart of the town. Towards the end of the seventeenth century, the town's numerous inns were able to offer a total number of beds for ninety-eight guests and stabling for 184 horses, thereby ensuring a considerable quantity of employment for local people.

Two further inns – the Red Lion and the White Horse – lay on London Road (now Dragon Street), thus providing the greatest convenience for through traffic along the north–south axis of the town. Just over half a century later, in 1726, Daniel Defoe described Petersfield as 'a

South Downs sheep.

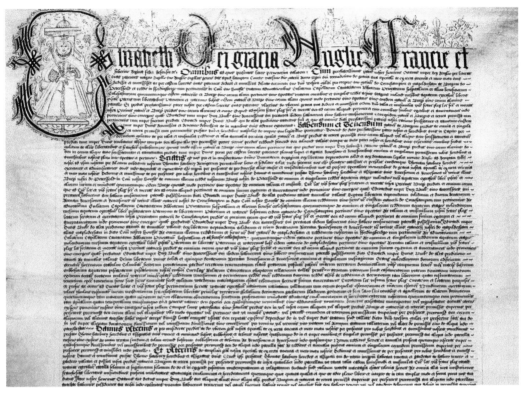

The charter granted to Thomas Hanbury, Lord of the Manor of Petersfield, 1597.

town eminent for little but it being full of good inns'. However, since it was also in the inns that business was conducted, their commercial importance was invaluable to the local economy. They also acted as meeting places for officials, such as those of the Turnpike Trust.

By and large, Petersfield's poor were adequately looked after, in comparison with those in other communities. The same might be said of the children of the parish: John Goodyer, an eminent botanist who had lived in The Spain (his house is now called 'Goodyers'), had died in 1664, bequeathing his property and land to his heir and nephew, Revd Edmund Yalden, so 'that all the yearly rents, issues and profits … shall be employed … for the putting forth and placing abroad of all such poor children'. For the past 350 years, many young people – both boys and girls – have been helped on their way in life by being placed as apprentices in many different occupations.

The White Hart's accommodation was clearly excellent – as confirmed by Pepys himself, who wrote that the king (Charles II) had stayed there in 1661. Pepys's own diary entries for the town are reasonably non-committal, but he passed through the town twice in 1662 on his way to and from Portsmouth, remarking that 'here we dined and were merry' and 'we dined well'. However, five years later, when the town had clearly been infected with the plague, he remarked that 'one side of the [High] street had every house almost infected through the town, and the other, not one shut up.'

In his book *Petersfield Under the Later Stuarts*, the historian James H. Thomas has calculated that the population of the town had reached approximately 1,000 (including children) by 1676, the majority living in comfortable homes. However, there was also some poverty and lawlessness, and the proximity of the main highways linking Petersfield to towns such as

'Goodyers', seventeenth century.

Winchester, Midhurst and Alton meant that highwaymen frequented the area. The main London–Portsmouth road (the present A3) became known as 'The Royal Road' thanks to its responsibility for transporting monarchs from the capital to the naval base; sadly, thanks to the presence of highwaymen, it also attracted the name of 'Assassins Road'.

As far as local industries were concerned, the most important and widespread of these in Tudor Petersfield were leather and cloth manufacture; however, by the mid-seventeenth century, both were waning in importance. Petersfield's regular cattle markets had provided raw material – from cattle and pigs – for leather production, including shoe- and glove-making. As with many market towns of this period, there would have been tanners and saddlers pursuing their trade for both the local markets and for external demand. In addition, some inns had their own brewing facilities on site. This not only attracted customers, but brought in expert craftsmen such as brewers, maltsters and coopers.

What has always characterised Petersfield since this period of its history is the dominant and compact central location of its Square and marketplace, the proximity of associated trades along the High Street, and the easy accessibility of passing traffic to its commercial outlets. The Square was resurfaced in the 1660s and the town's market house (now demolished) was built there in the 1680s. Around the Square there were the shambles, stalls selling not only butchers' produce but other wares to complement the meat on offer – just as today, nearly 400 years later.

Hatton's Mead, 1611.

THE GEORGIAN PERIOD

By the end of the eighteenth century, Petersfield was home who would have employed many townspeople in their service. The Jolliffes, originally from Staffordshire, exerted both a political and a commercial influence on the town's affairs. When they vacated their sixteenth-century manor, Castle House (in the Square, where the Post Office and HSBC bank now stand), they built Petersfield House (on the site of the old police station, now the town museum). The Bonham family bought Castle House in 1749 and their family remained there until the 1820s, when they married into the Carter family of Portsmouth, creating the Bonham-Carter dynasty.

Both families contributed to the town's wealth and wellbeing by participating in the local volunteer unit, the Petersfield Infantry, acting as magistrates, overseeing improvements to the town, or adding to the town's sporting reputation with their own cricket teams. It was thanks to John and William Jolliffe that the Petersfield Poor House in Swan Street was established in 1771. This allowed the poor of all ages to be lodged, maintained and employed at such tasks as 'picking stones' or 'weeding'. The inmates were generally vagrants, but the poorhouse also occasionally housed wounded soldiers or sailors and local tradesmen often delivered goods there.

The link between the local landed aristocracy and trade can be said to date from this period. Joseph Patrick, for instance, a member of the brewing family, was steward to the Jolliffe estate; he lived at Dragon House in Dragon Street and other servants of the estate lived in the cottages still adjacent to this large property. In 1713, John Jolliffe acquired the land and dwellings situated on Hatton's Mead in Horn Lane (now Heath Road). He added a dwelling house and malthouse on the site.

Two major political decisions affected Petersfield's commercial standing at the beginning of the seventeenth century: the founding of Turnpike Trusts and the transformation of the landscape through the parliamentary Enclosure Acts.

The Portsmouth and Sheet Turnpike Trust, created in 1711, brought prosperity to several new inns on the Portsmouth Road and to everyone connected with the coaching business. The ownership of the White Hart and the Green Dragon, for example, passed from one generation to the next, thus ensuring the names and the fortunes of these families. At the same time, those craftsmen associated with each of the private inns would have had the certainty of guaranteed employment.

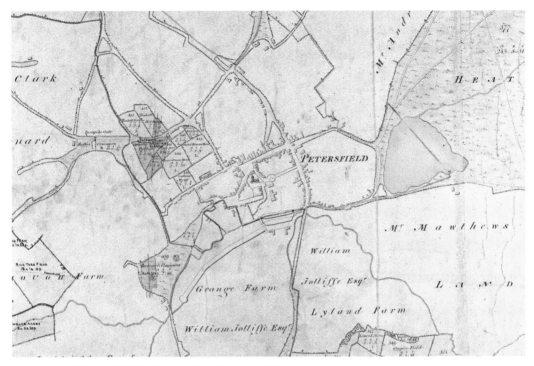

Stawell Map of 1793. (Hampshire Record Office)

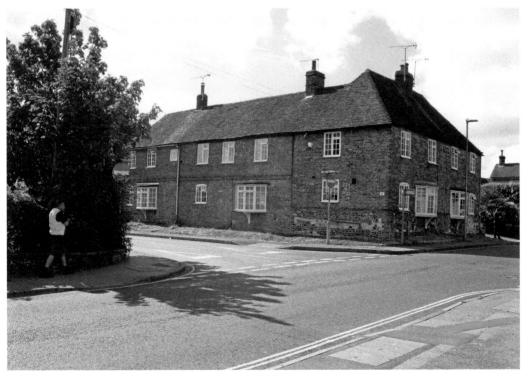

Swan Street Poor House, 1771.

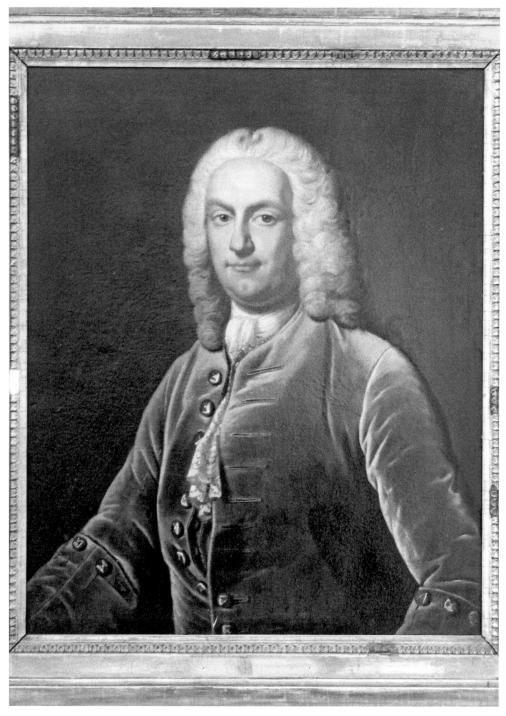

John Jolliffe, MP for Petersfield, 1741–54.

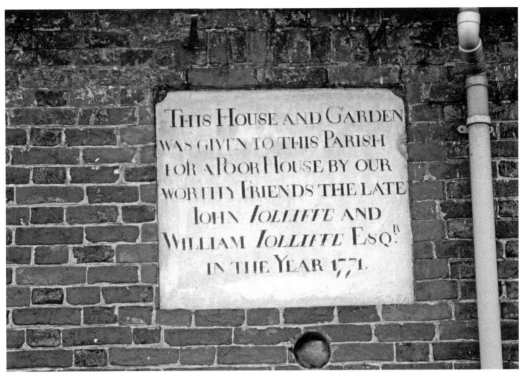

Plaque on the Poor House.

The old Green Dragon, eighteenth century.

Rowans – part of the old seventeenth-century White Hart.

The majority of land enclosures took place between 1750 and 1850 and the newly established arable open fields created out of previous 'wastes' – less productive land with poorer soil – would bring similar new prosperity and employment to those engaged in agricultural work. Petersfield, like other ancient boroughs, had been governed for centuries by its lords of the manor and the Enclosure Acts ensured that commoners were granted rights to the common land in their communities. The large landowners – in Petersfield's case the lords of the manors of Petersfield, Buriton, and Sheet, along with Magdalen College, Oxford – began slowly to release individual plots to private individuals, who turned them into profitable agricultural or commercial enterprises.

The coaching era proper could be said to have reached its peak with the introduction of the mail coach – designed at the end of the eighteenth century – which added a whole new commercial aspect to the erstwhile private service in horse-drawn transport. Mail coaches were four-wheeled covered coaches adapted to carry the royal mail. They were drawn by teams of four horses in stages of around 7–10 miles according to gradients and the condition of roads; in Petersfield, for instance, they would have had to negotiate the steep climb over Butser Hill on their way to Portsmouth. As an overnight stop, they used the Dolphin Inn on the corner of the High Street and Dragon Street (demolished and replaced with Dolphin Court in 1968).

In addition to the age-old crafts of previous centuries, Petersfield in the eighteenth century saw the emergence of two new industries: brick-making and brewing.

Butser Hill, Petersfield

Old Butser Hill.

Medieval builders were the first to appreciate the quality of the clay around Petersfield and they exploited it to make both bricks and tiles. Claypits were to be found at Stroud and at brickworks in the Causeway in the eighteenth century (this later became Nightingales Brickworks). A number of cottages built from bricks at these works were used as homes for the yard's workers and their families. The heavy manual work began with extracting the clay, which was dug out by hand. It would be loaded onto barrows and taken to be mixed with clinker, then put in a pug mill to be ground until it became a fine, pliable mixture. The grinding work was carried out by horse-power, then the mixture was put into moulds to dry. Finally, it was fired in kilns. The quality of Petersfield clay was such that it was in demand from other parts of the country. The local brickworks remained in operation until the start of the Second World War.

The hinterland of Petersfield is primarily agricultural, growing grains including barley, dairying and rearing livestock. The brewing industry fits into this pattern, its two essential raw materials being barley and a good supply of water. There are many historical records of malthouses and maltsters in Petersfield processing the grain for the brewers. Hop pickers mainly came to the large hop fields in Weston and Buriton, although they mostly consisted of Portsmouth families coming to Petersfield especially for the season in late summer. Local workers, however, were responsible for the early stages of this process: ploughing, cutting, stringing, training, spraying, and the final stage of drying in the hop kilns.

Small family brewers began to become established in Petersfield in the mid-eighteenth century. A c. 1750 map marks Edward Patrick's brewhouse on the corner of Heath Road West and Sussex Road, while a 1784 directory lists Mr Patrick as a 'Common Brewer' and Edward Perryer as a 'Brewer'. Christopher Crassweller's brewery was located to the south of The Spain (in the garden of the present No. 6). At No. 7 The Square there was a pub brewery owned by the Holland family from 1739 to the 1850s – this is now the Square Brewery. This trend of family orientated innkeeping was to develop further during the nineteenth century, with businesses extending into other fields – the Monk family, for example, traded at The Sun Inn (in Dragon Street, where the JSW restaurant is now located), and Henry Monk, the owner, was also a corn and hay dealer, with a horse and carriage for hire. Many Petersfield inns dated back to the eighteenth century, however, and have only recently disappeared – the Anchor and the Bear were also in Dragon Street, the former owned by a bricklayer, while the latter was owned by a glove-maker. It suggests that, certainly in the first half of the century, innkeeping was not sufficiently profitable to make a living by itself and it was necessary for licensees simultaneously to ply other trades.

As the century progressed, the developing coaching trade brought more customers – and therefore wealth – to the town, and by the beginning of the nineteenth century visitors such as William Cobbett commended the stabling in 1825, while, even later, Charles Harper wrote: 'the courtyards and coach-houses of the Dolphin are a sight to see and wonder at'. Public service coaches were travelling day and night from Petersfield, some wagon train coaches being drawn in convoy by teams of eight horses, thus demanding even better services from farriers, coach repairers, ostlers and stablemen working in the stables behind the town's inns. The coaching era represented one of the most important industries in the town at this time.

The growing prosperity of Petersfield was marked by the founding of its first bank in 1718, and it was Jane Austen's brother, Henry, who later ran it in partnership until 1814. To illustrate the confidence of the town's landlords during this period, we can cite Thomas Jaques of the White Hart, who, like other traders, issued his own trade tokens when copper coinage was short. Petersfield also saw an increase in traffic due to soldiers passing through the town on their way to fight France in the Revolutionary and Napoleonic wars.

Above: Stroud brickyards, 1930.

Right: A Stroud brick.

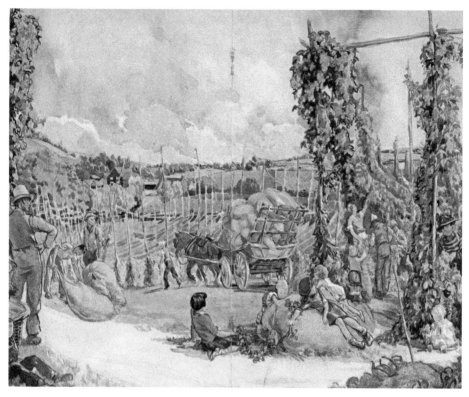

Hop picking (by local artist, Flora Twort). (Petersfield Museum ref: FA1985.3.15)

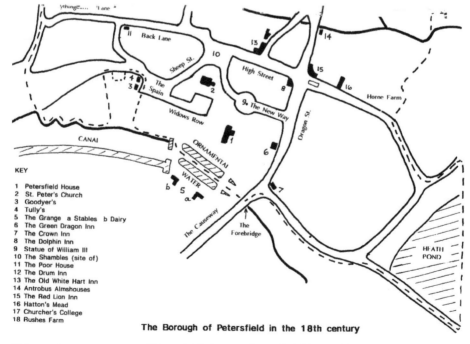

KEY

1 Petersfield House
2 St. Peter's Church
3 Goodyer's
4 Tully's
5 The Grange a Stables b Dairy
6 The Green Dragon Inn
7 The Crown Inn
8 The Dolphin Inn
9 Statue of William III
10 The Shambles (site of)
11 The Poor House
12 The Drum Inn
13 The Old White Hart Inn
14 Antrobus Almshouses
15 The Red Lion Inn
16 Hatton's Mead
17 Churcher's College
18 Rushes Farm

The Borough of Petersfield in the 18th century

Eighteenth-century centre of Petersfield, showing Petersfield House. (Courtesy of Eric Leaton)

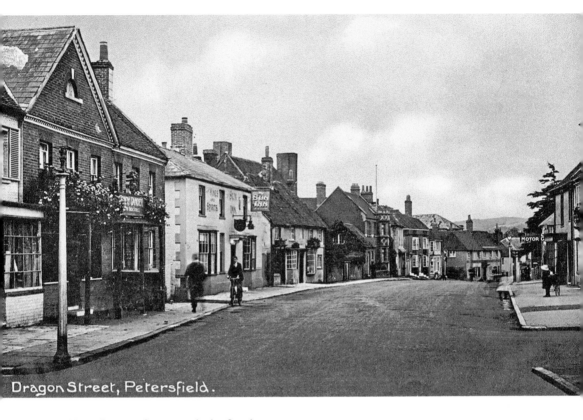

Dragon Street, Petersfield.

Above: Dragon Street, with the Sun Inn.

Right: The Petersfield Halfpenny. (Courtesy of Alicia Denny)

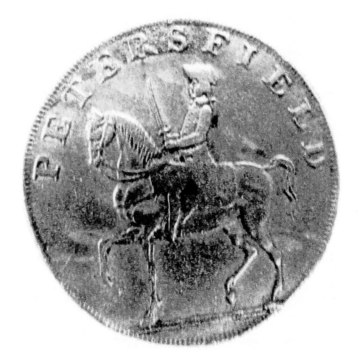

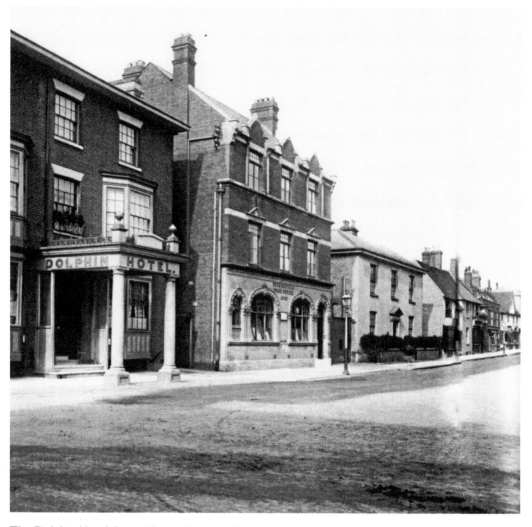

The Dolphin Hotel (late eighteenth century).

With a severe shortage of small denomination coins for everyday commercial transactions, Petersfield, in common with several other towns, produced its own provincial token known as the Petersfield Halfpenny in 1793. These coins could be exchanged for food or other goods and were inscribed with their issuing tradesmen's names; for example 'Eames, Holland and Andrews, Petersfield', grocers and brewers in the town.

THE VICTORIAN ERA

At the turn of the nineteenth century, the possibilities of local employment for Petersfield's inhabitants still remained largely with the farms, in the numerous inns, or in private houses. However, both politically and socially, the town was changing in character. The population was around 1,500 but, by 1832, the new borough had extended its limits to include the parishes of Buriton, Liss, Froxfield and most of Steep. Although succeeding members of the Jolliffe family still remained lords of the manor of Petersfield throughout most of the century – therefore keeping their control of the land and those people associated with its exploitation – they had lost their family seat in 1793 with the demolition of Petersfield House (where the present Petersfield Museum stands) following a conflict with local residents.

When the Union workhouse opened on Ramshill in 1836, some of its 152 destitute inmates – of whom several had fought in the recent Napoleonic Wars – would be employed locally on a daily basis. The workhouse also owned 2 acres of ground on which pigs were kept and vegetables were grown, thus helping the inmates to maintain their own self-sufficiency and, no doubt, their self-respect.

Children of the poor were also put to work, apprenticed to anyone prepared to take them off the parish's hands. Some were sent to district schools run by the Poor Law Guardians, while others were given work as servants in the workhouse, with private families, or to local businesses. The first national school (since demolished) was opened in Petersfield in the present Sussex Road in 1837.

Life was generally hard in rural Hampshire in the 1830s, and Petersfield was no exception to this rule. One example of such hardship, but also of individual enterprise, was that of William Holder, a young member of a large local family, who, as a boy apprentice, had found plenty of work, thus enjoying food and sound sleep, and attending church on Sunday mornings. Some of his contemporaries went to London to improve their wages, or they chose to be drafted into the local militia. His grandfather had been a carpenter, but the new generation, with their London-acquired knowledge, was prepared for any kind of work, which they soon secured. By the 1840s, William wanted to become a joiner, but a small town did not offer much choice. With his uncle, he undertook a variety of jobs: cutting down trees in Adhurst Wood to transport to Petersfield, being employed in paper-hanging, painting, glazing, or making cart wheels or shafts for carts.

The Union Workhouse today.

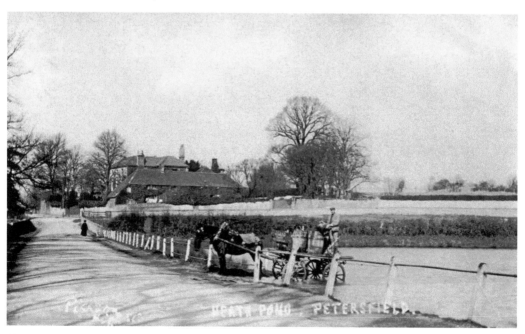

Cart filling in Heath Pond.

Members of the Holder family in Victorian times.

Taro Fair, 1906.

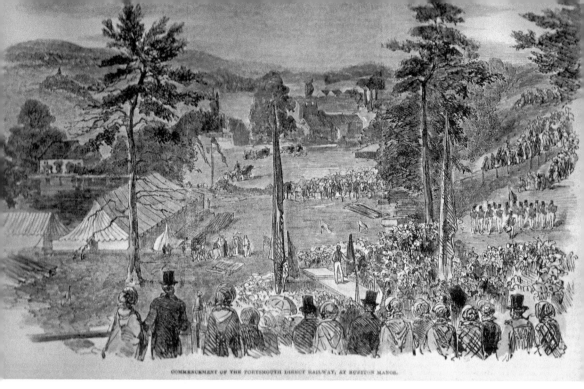

COMMENCEMENT OF THE PORTSMOUTH DIRECT RAILWAY, AT BURITON MANOR.

First turf cut for railway, 1859.

Some relief from the general poverty of the town came with the introduction of the Taro Fair on the Heath in 1820. The fair was principally the venue for the sale of cattle and sheep; however, side stalls, roundabouts and other forms of entertainment were added later and generated a welcome amount of popular appeal.

In the first few decades of the nineteenth century, improvements in coach design had reduced the journey time from London to Portsmouth to just eight hours, with the new 1826 Butser Hill cutting – the biggest such project in the country – helping to reach this goal. The increase in coach speeds brought a decrease in highway crime; it was also safer to travel by the new generation of mail coaches, which made fewer – if any – stops on their routes.

The start of the century also saw the birth of hotels, built to meet the new demand from people wanting to stay more than one night in the town. It prompted the rebuilding and expansion of the old inns, The Red Lion and The Dolphin, which remained Petersfield's only hotels until the coming of the railway in 1859. Meanwhile, Edward Patrick and his son acquired several breweries in the town, and George Henty, the Chichester brewer, also had multiple brewing properties in Petersfield.

One clear snapshot of the types of employment available in Petersfield before the arrival of the railway is revealed by the 1851 census: in College Street, for example, a characteristically residential area inhabited by all classes of society, there were thirty-six properties, including almshouses, households headed by paupers, and one occupied by a blind single woman, two married couples and a widow and her dressmaker daughter.

There were three householders listed as boot and shoemakers, one of whom also accommodated a journeyman bootmaker and an apprentice, while there was one general dealer, accommodating a shopkeeper and two porters. The census shows the presence of an ironmonger, a watch and clockmaker, a baker, a grocer, a tailor and other self-employed tradespeople.

Some craftsmen householders were employers in their own right: a stonemason employing five men, and a bricklayer employing three. There were three gardeners or seedsmen, one blacksmith, a carter, a postman and four labourers. Five householders gave no occupation and were therefore probably of independent means or the proprietors of houses. There were also twenty living-in servants.

Predominantly, therefore, Petersfield showed itself to be a town of craftsmen and retail workers, housing young and old in equal measure, and providing the services required by all generations: hospitality, schools and churches, building firms and local shops in abundance. One surprise, perhaps, is the lack of direct reference to agriculture, although it is likely that most farmworkers were accommodated directly on farm premises in the locality.

It was a different story in the local villages, however, where the main occupation for men was farming, both arable and dairy. Living conditions were still relatively primitive: there was no gas or electricity (oil lamps were used), no mains drainage or water supply, and residents had lavatories at the bottom of the garden. Most people either owned a farm or worked on one, and villages had their own cobbler, midwife, village shop, school, forge and ancillary trades. The only industries in Steep, Stroud and Froxfield during the nineteenth century were agriculture and brickmaking; a local forge also supplied the necessary tools and expertise for these to survive. The sharp distinction between the gentry and the poor still prevailed,

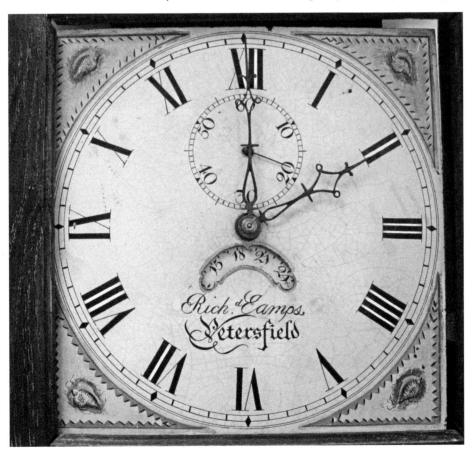

Clock by Richard Eames of College Street.

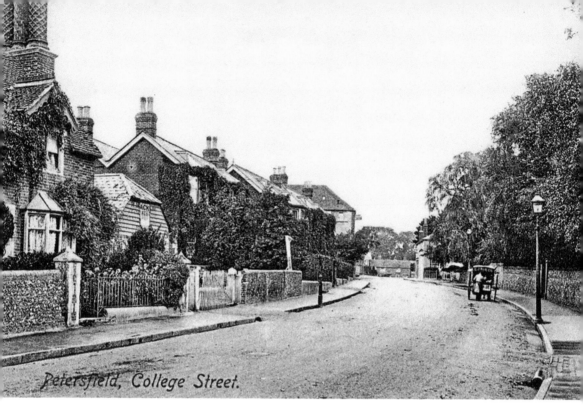

Petersfield, College Street.

College Street.

and due deference was accorded by the latter to the former. Meanwhile, while the gentry remained affluent, the poor had to practise good husbandry – vegetable growing and pig rearing – to supplement their very low wages.

Undoubtedly, the most important decade for improvement during the nineteenth century in Petersfield was the 1850s, when a new national school was built for over 300 children, gas lighting was introduced in the main streets of the town, a police station (now the Town Museum) was built and, most importantly of all, the railway arrived in 1859. This was the final link, connecting Haslemere to Havant, which ensured Petersfield's direct access to both Portsmouth and London. These developments corresponded to a general, national transformation of people's lives with greater urbanisation and better communications, allowing greater physical and intellectual freedom for millions as they fled the land, villages and poverty.

The beginning of the nineteenth century had seen both the acceleration and peak of the coaching trade, but also its sudden collapse with the railway revolution. In Petersfield, it was the arrival of the railway that was directly responsible for stimulating new growth in the town, and the old rural industries – such as tanning, weaving and spinning – tended to diminish in importance.

A major shift in employment opportunities occurred in the mid-nineteenth century when the incipient industries linked to the breweries and dairies in the town began to provide the main sources of employment for Petersfield and its growing population. Four large breweries dominated the market: George Henty owned several malthouses behind Dragon Street and eventually merged with Constable & Son of Arundel to form the Westgate Brewery in Chichester; Christopher Crassweller ran a brewery at the rear of Hylton House in The Spain (later Moreton House and now No. 6 The Spain); Thomas Bone and Robert Crafts both operated in College Street, Bone being succeeded by Andrew Gammon in 1867 and

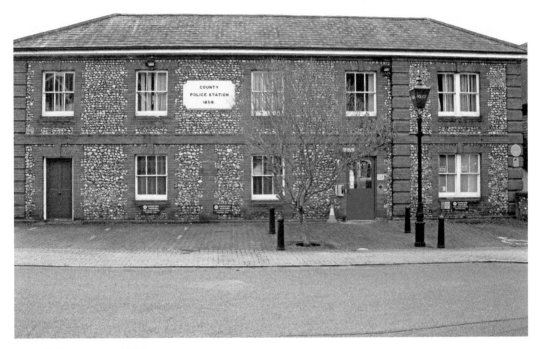

Police station, 1858.

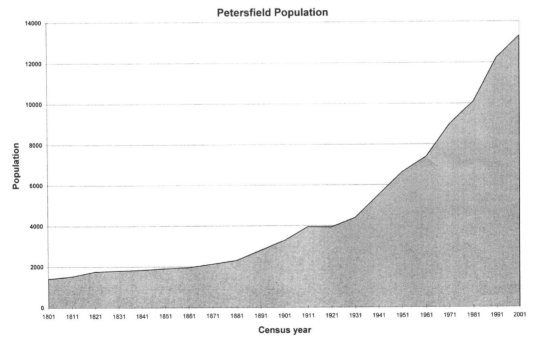

Petersfield population growth 1801–2001.

Crafts sold his business to two brothers, William and Robert Luker, in 1880. The Luker brewery building in College Street dominated the whole town from its central position; it also provided a considerable source of employment for Petersfield men who were responsible for overseeing the great vats and tuns containing the beer, controlling the fermentation process and bottling procedures, and supervising the cellars and bottle store below.

In addition to these major breweries dominating the market, there were still numerous home-brew houses that had been in existence since the eighteenth century. In the 1860s, for example, Walter Seward brewed at the Royal Oak in Sheep Street (now The Black Sheep) and William Fitt, a coach maker and builder, was brewing at the Market Inn on the Square (now Joules).

The Victorians had always considered that the land surrounding Petersfield was better suited to pasturage than to tillage. The sandy soil with a mixture of chalk from the Downs and clay from the Wealden bed allowed the growth of a quality of grass better adapted for cattle grazing than any other part of Hampshire – hence the high quality of milk produced in the local dairies, of which there were many in the town in the Victorian period. By the end of the century, the number of dairies indicated the importance of the industry to Petersfield. The six principal outlets were Aylwin's in Hylton Road, Hunter's in the High Street, Norman's at Herne Farm, Smart's in the Causeway, Corbett's also in the High Street, and Heward's Lythe Farm at Steep.

Linked to the development of both these industries was the growth in importance of the local engineering and haulage firm of W. Seward & Son, founded by Walter Seward in 1886 and operating from a large workshop in Chapel Street. Indeed, the link was firmly cemented in 1899 when William Luker married Florence Helen Seward, the youngest daughter of Samuel Seward of Weston Farm.

Walter purchased his first traction engine in 1886, along with a threshing drum and elevator, which successfully served local farmers at harvest time. Ten years later, he bought his first steamroller for road building projects, and the firm also became contracted to carry building materials to Longmoor for the construction of the Army camp there.

It was the business community in Portsmouth in the 1840s who demanded a more direct rail link to London (then only connected via Brighton or Southampton), and it was the highly regarded railway contractor, Thomas Brassey, who now responded to the businessmen's demands. Brassey sought and obtained the powers to build a line from Godalming through the market towns of Haslemere and Petersfield to a junction belonging to the London, Brighton & South Coast Railway at Havant.

Despite the problems involved in overcoming the terrain and the gradients of the Weald and the South Downs, there was a significant improvement on journey times to and from the capital and this in itself delighted the inhabitants of Portsmouth. The line was an immediate benefit for Petersfield, which was provided with a much needed service to Guildford and Waterloo.

A branch line from Petersfield to Midhurst opened in 1864, providing Petersfield with an efficient west–east link for such traffic as milk transport and other goods and it lasted for almost a century before being finally closed early in 1955. Long lines of freight wagons carried the early traffic on this line, and a special platform was built opposite the Petersfield signal box, which eventually carried the milk churns from the South Eastern Farmers' depot to Midhurst. The line came to life in Goodwood Week, when there were additional trains, especially horse trains, with horse boxes attached.

The advent of railway travel made an immediate impression on the town in the 1860s and brought with it a surge in building work for at least two decades. The very position of the railway station (in the middle of fields, barely half a mile away from the centre of town) ensured

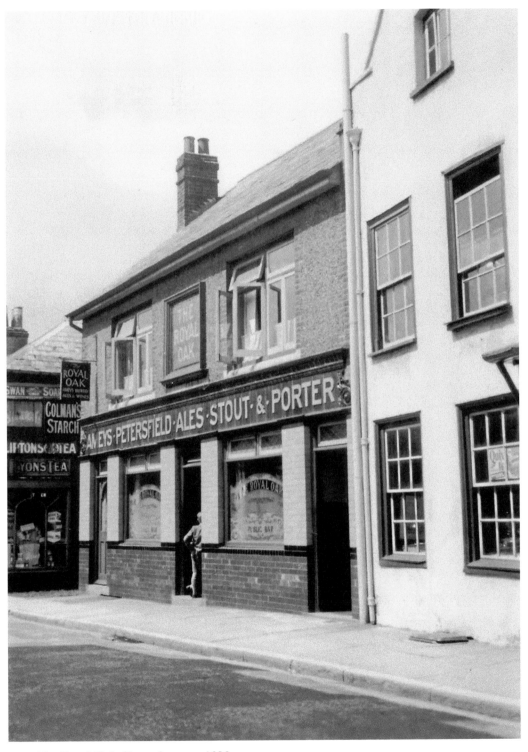

The Royal Oak, Sheep Street, *c.* 1930.

Dairies' adverts, 1908.

that a link to the town could soon be realised. In the 1880s, the construction of elegant houses the length of Lavant Street, smaller terraced houses in Charles Street (prosperous new four-bedroom villas and terraces in Station Road), and new villas and shops in Chapel Street were signs that the town was increasing both in population and prosperity. During that decade Petersfield's population rose by 300 and there was a concomitant decrease in

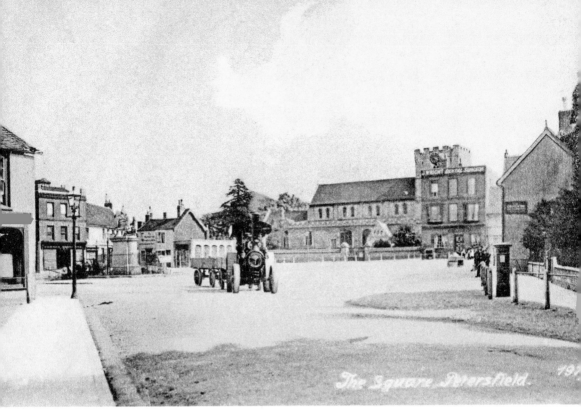

Above: Sewards of Petersfield.

Below: The Midhurst line.

the population of outlying villages during the same period. The population rise – reaching 3,000 by the 1890s – brought a need for more shops and this retail trade provided many job opportunities.

At the same time as these physical changes, political and social advances in the town enhanced its status as a prosperous and well-established community: the police station opened in 1858; the town's Cottage Hospital opened in 1871; Churcher's College's new building on Ramshill arrived ten years later; the first working men's club provided a recreational centre for men who had little money for entertainment; the Petersfield Cricket Club was formed in 1883; the town's first post office, located in College Street since the mid-century, moved to the High Street (where Rowswell's now stands) in 1870, then to an imposing building adjacent to the old Dolphin Hotel in 1893. Finally, the newly formed Urban District Council, set up in 1894, gave Petersfield an administrative focus and political base, thanks to which the town's 'worthies' could channel its future development.

The relatively small number of prominent people involved in the town's affairs in the closing years of the nineteenth century were no longer from the traditional aristocracy – the erstwhile lords of the manor – but from a background in what was loosely (and patronisingly) called 'trade'. They were the products of large Victorian families and their associated Victorian work ethic, which ensured their survival over many generations and were destined to guarantee the reputation of the family name. When two such families were brought together by marriage, their combined status and commercial power benefited both their families and the town as a whole.

Several such marriages took place in the 1890s: William Luker, the eldest son of Robert Luker, the co-owner with his brother William of Petersfield Brewery in College Street, married Florence Helen Seward, the youngest daughter of Samuel Seward, the last mayor of the borough of Petersfield and the owner of the large farm at Weston known for its hops.

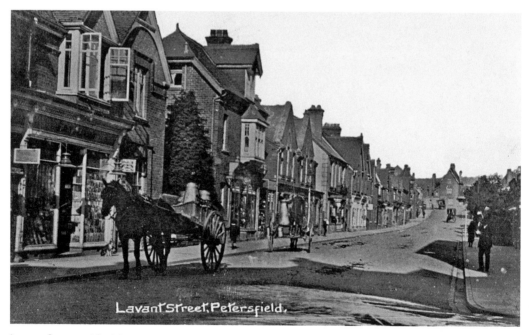

Lavant Street with dairy carts.

20 The Cottage Hospital, Petersfield.

The Cottage Hospital, 1871.

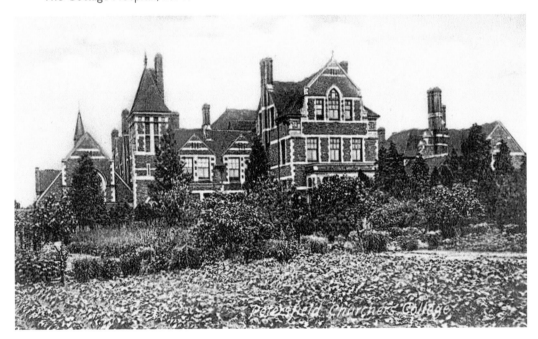

Churcher's College, 1881.

Luker's ales bottle labels.

A second alliance was that between Edward Talbot-Ponsonby, the eldest son of C. W. Talbot-Ponsonby of Langrish House, and Marion Nicholson, the youngest daughter of William Nicholson of Basing Park, who served twice as Petersfield's MP.

Finally, a further such alliance occurred when the twice-widowed Andrew Gammon married Alice Holder at the turn of the century, thus strengthening the two local families' links in Petersfield. There have been Gammons in Petersfield for over 300 years and, by the beginning of the twentieth century, they were involved in four businesses: as coal merchants (with a yard by the railway station), as linen drapers (at Manchester House in The Square, now Caffè Nero), as builders merchants and contractors (in College Street), and as a brick and tile maker and farmer (living at Herne House in Heath Road).

Another well-established family in the town – that of William Mould – combined the trades of dairy farming and building. A so-called 'Jersey Dairy' had been started in the town in 1849, probably by William Mould Snr, a local dairy farmer, but in the 1880s his son began a building and funeral business at his father's dairy premises in Chapel Street. The family firm moved again in 1900 to Dragon Street, where the outbuildings were used as workshops for carpentry and a monumental mason's shop.

By the end of the Victorian era, there were approximately 500 houses in Petersfield and the population had doubled since the beginning of the century, from around 2,000 to 4,000.

Characteristics of the nineteenth-century commercial development of Petersfield are: the interaction between lords of the manor and the population at large; the co-existence of large companies and smaller, even family, units of business activity in specific fields; and the shift away

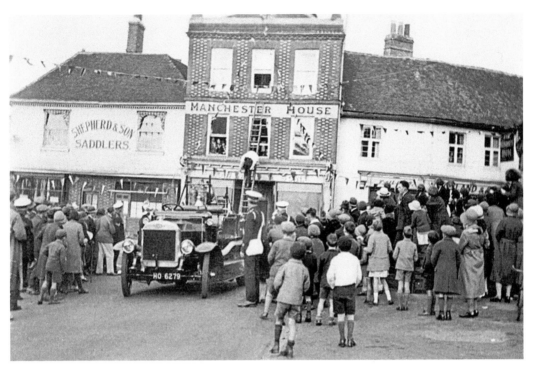

Manchester House, the Square.

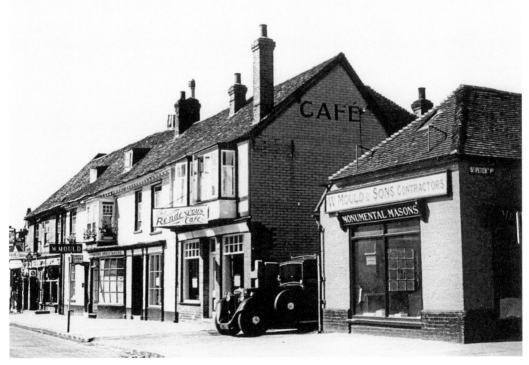

Mould's, Dragon Street.

Victorian terraces in Station Road, 1876.

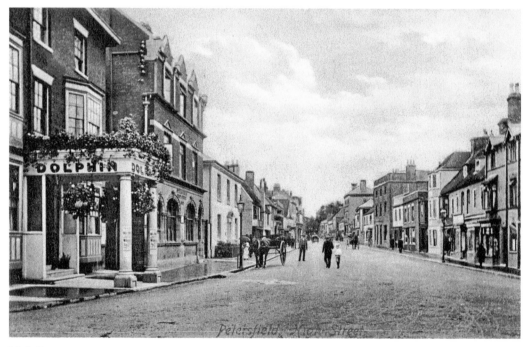

High Street.

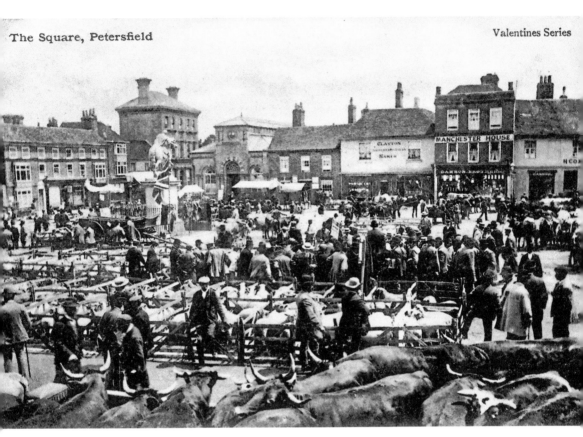

The Square, Petersfield Valentines Series

The Square on market day.

from agriculture to a large variety of both associated trades and new, smaller industries. The dual appeal to the working population was clear: there was no single overwhelming industry in the town dominating the business community, thereby reducing job opportunities, and there was a variety of openings for workers both young and old in the town. This eclectic mix of independent retailers and craftsmen, powerful family firms and nationally known outlets is still reflected in Petersfield's hybrid character today.

THE MODERN ERA

B y the end of the Victorian era, new towns and industries were growing up throughout the country. Developments in public and private transport, new housing, paved roads, street lighting, telephones and gradual urbanisation were changing people's lives. This slow but noticeable metamorphosis of the country made itself particularly felt in Petersfield, where such changes to the town enabled local people to find a greater variety of work opportunities.

The agricultural sector had been in sporadic crisis since the 1870s, and it was hardly surprising that many young families chose to emigrate to Canada or Australia. Notices in the press in 1893 announced that two local farms at West Harting and Steep were being sold by auction, together with all their livestock – working horses, heifers and steers, cows and calves, geese and poultry, bulls and pigs. The same year, the sale of valuable freehold building sites within Petersfield came onto the market, revealing the fact that the town was extending its boundaries and thereby enlarging its population. The shift of emphasis from the town as a purely rural entity to that of a small suburban centre had begun.

At this time a shift also occurred in gender roles, as women began to seek work: working-class women found jobs in domestic service and manufacturing, while their middle-class equivalents went into teaching or nursing. As elsewhere in Britain, Petersfield's wealthiest inhabitants began to build themselves detached villas, while the labouring classes followed the rhythm of the countryside as they had done for centuries.

The ambience of Petersfield in Edwardian times was characterised by its High Street, a thriving centre of activity, with tradesmen and businessmen in abundance, servant maids doing the shopping, children with their nannies, nursemaids pushing perambulators, and ladies wearing hats and gloves, their long dresses held up out of the dirt. Petersfield was a town in transition, an expanding community governed by the wider forces of unequal prosperity, social change and material progress.

The town's growing prosperity was reflected in the elegant department store of Thomas Privett in the Square and the four high-quality grocery firms of J. P. Cordery in College Street, W. T. Neighbour's in the Square, Fuller's in Lavant Street and the International Stores in Chapel Street. Fashion shops for both men and women began to spring up in the early years of the century – Norman Burton's in the Square, Rickard's in College Street, Wells and Rush in Chapel Street.

The Laurels in Station Road (1898).

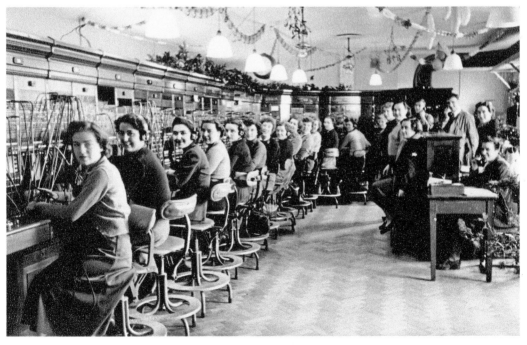

Petersfield's first telephone exchange.

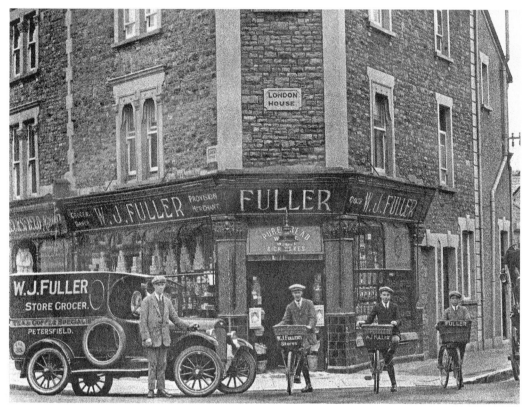

Fuller's grocers, *c.* 1920.

North side of the Square, *c.* 1910.

Rickard's, c. 1920.

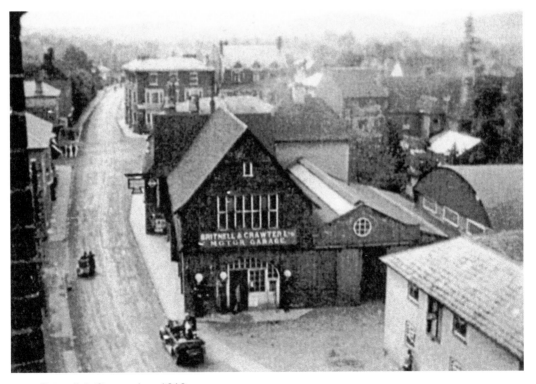

Britnell & Crawter's, c. 1910.

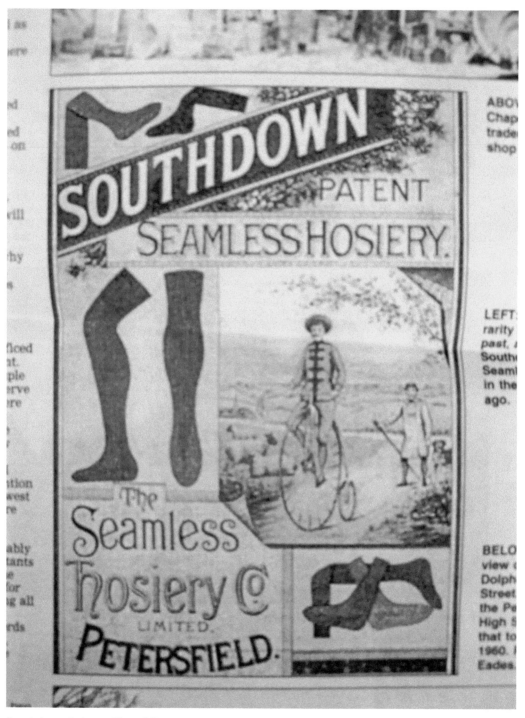

Southdown hoisery, Chapel Street.

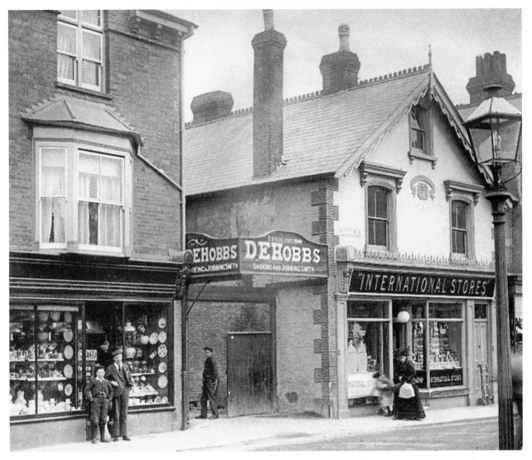

D. E. Hobbs and the International Stores in 1910.

The arrival of the motor car produced the first garages in town: Britnell and Crawter's were established in College Street in 1907 and their garage (now the Folly Market) advertised itself as 'Cycle and Motor Agents and Makers'. They also boasted one of the first telephones in Petersfield, underlining the new century's business acumen for its customers. As the motor car gradually displaced the horse and trap as a common means of locomotion, so the erstwhile trades associated with the latter became redundant. The most prominent of the town's blacksmiths was Mr D. E. Hobbs, who had begun business in the town in 1876. He passed on his business to his son and, as Hobbs & Son, they traded in the construction and repair of carts and vans from new premises in Station Road and Swan Street, providing 'every description of carts, vans, wagons, lorries, built to order on the premises'. They were an excellent example of a family business adapting to the times.

With the death in 1907 of John Gammon, whose home was at Herne House, Petersfield lost a large employer and one of the chief property owners of the town who had helped to shape the town itself. His father had been a carpenter and builder in Petersfield and, with his brother Andrew, the firm of J. and A. Gammon thrived for many years, becoming J. Gammon & Son when his son, T. G. Gammon, joined them. They were the chief building firm in the district until 1904, when they were taken over by their rivals, Messrs J. Holder & Son. John Gammon

Above: Gammon properties overlooking the Heath, 1900–05.

Left: J. Gammon & Sons monogram in College Street.

was responsible for building properties in Tilmore Terrace, Madeline Road and Penns Road (all built on land purchased from the railway company after the Midhurst line was constructed), most of Charles Street, the row of shops in Chapel Street, and the villa residences overlooking the Heath. To his building operations, he added farming and hop-growing. He had purchased Herne House and farm in the 1870s, then farms at Bolinge Hill, Buriton and Langrish. He further developed into brickmaking and ran brickworks in Steep Marsh, Liss and Stroud.

Another member of an old family in the town died in 1903: William Mould, who had been one of the few surviving links with Petersfield from the early Victorian days. He died at the then remarkable age of eighty-six. He was best known as the lessee of the market, but had also been a farmer, corn merchant and dairyman, living at Buckmore Farm and carrying on his building and funeral business in Chapel Street for sixty years. In 1900 he moved this business to Dragon Street at the corner of St Peter's Road, and used the outbuildings there as a carpenter's and monumental mason's shop.

By 1911 the population of Petersfield stood at 3,947, a rise of approximately 20 per cent over the previous decade.

At the outset of the First World War over 200 men were recruited in the first few days to the Petersfield Company of the 6th Hants Regiment. As men left their employment to

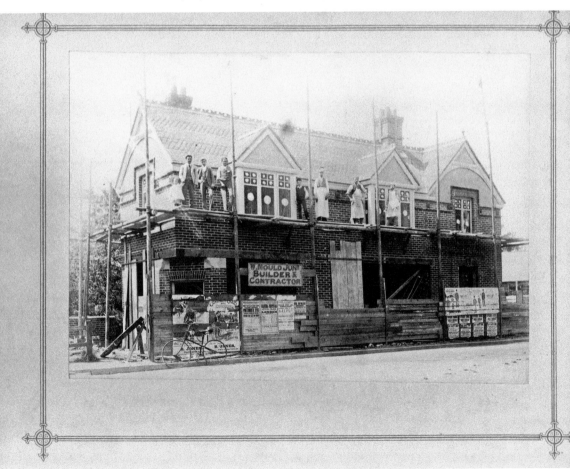

Mould's building in Lavant Street, 1880s.

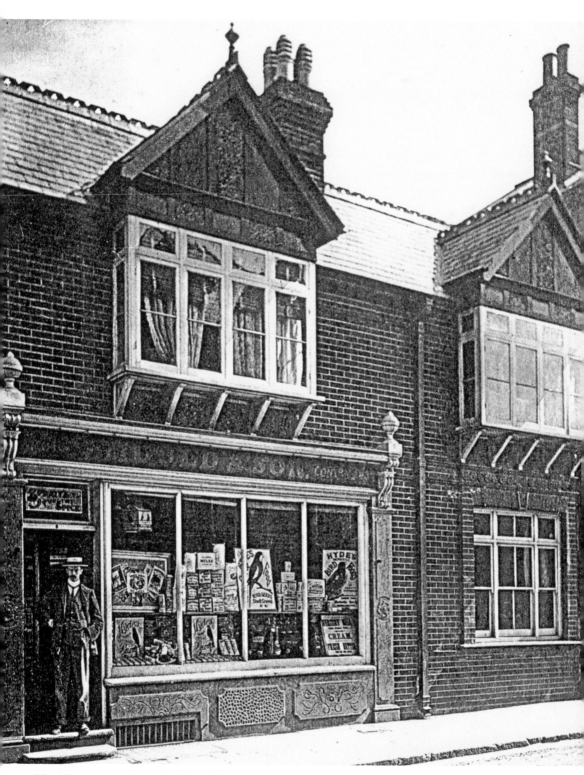

Mould's corn merchants in Chapel Street.

281)

d Sussex News,

E PETERSFIELD WEEKLY NEWS."

JULY 5, 1916. ONE PENNY.

PETTY

3.

re Messrs. H. S.
A. E. Cotton. L.
we Bennion.

ce of the Temple
1 John Dunce to
ed the Army.

—Sidney Charles
, was summoned
common danger
a requested by a
June. Mr. Percy
defendant, who
es.—P.C. Jackson
1 question he saw
ar in the Square,
Bramshott Camp
ross roads at the
the station. As
vas on the wrong
as sounded as a
e men on picquet
ut of the way to
As the motor car
nta the centre of
as a signal and
stop. Defendant
as he passed him
he commenced to
for 30 or 40 yards,
speed and drove
affic about at the
less subsequently
why he did not
e you." Witness
it such a fast and
What speed was
his opinion, 30
d the car would
the speed round
hour. Whilst wit-
n with defendant
alled a man out
through Liphook
al Albert Cale,
was in charge of
1en and another
ght if there had
there must have
l the pace of the
at 25 to 30 miles
en going through
a cross-examina-
ee a motor cyclist
the defence, said
1e pace he was
t he came round
were numerous
:arp, and he was
The hooter was

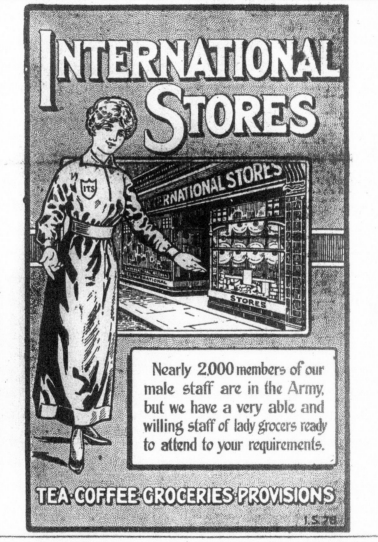

against Mr. Alloe, and dismissed the case against Mr. Raymond.——William Edney, of Lovedean Farm. Catherington. was also summoned for not

road to feed from. He found the defendant in the centre of Pratt's shop, which was about 14 yards away. Defendant now said there was a

First World War related poster for International Stores.

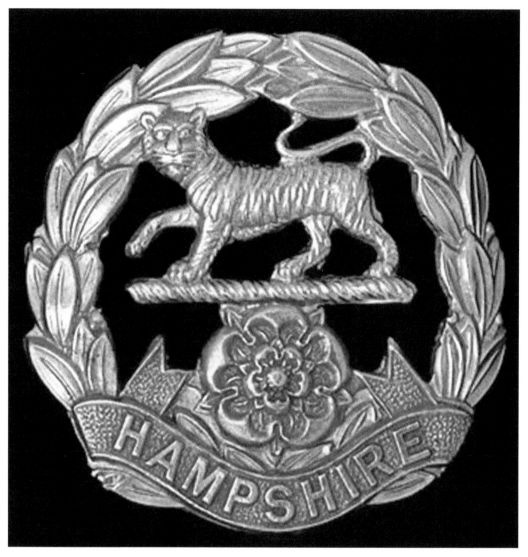

Hants Regiment badge.

be recruited, farmers suffered from the loss of their men and horses and a mutual help arrangement was set up to bring in the harvest. To fill the labour gap, Petersfield Scouts found themselves employed by the Post Office, the police and others in delivering messages regarding the mobilisation of troops and the requisition of horses. Countless schoolchildren and women were employed fruit picking and hop picking. Businesses in town had to find alternative means of transport and delivery.

As farming underwent enormous changes in the following twenty years, with increased mechanisation, the devastating effects of the First World War on the farming community and on women entering the workforce out of necessity, Petersfield witnessed an increasing diversity in its employment opportunities. The shift from a predominantly single labour-intensive workforce engaged in agriculture to a multifaceted small-scale industrial and

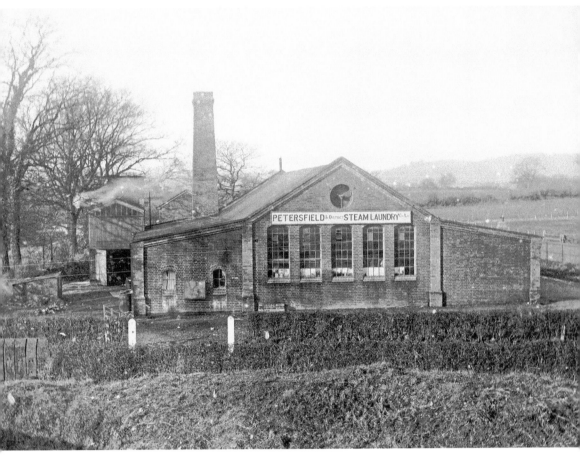

The Petersfield & District Steam Laundry in The Rushes.

commercial community had begun. The Corn Exchange, built in 1866 for local cereal farmers to conduct their transactions, became a major indoor venue for public entertainments.

The emergence of several larger-scale employers in the town began with the arrival in 1899 of The Petersfield & District Laundry Co. Situated in the Rushes (now Frenchmans Road), it attracted special praise in the local press as an example of a prosperous industry, representing 'many possibilities of good for the neighbourhood'. In an article explaining the intricacies of the various processes at work, it demonstrated that the laundry had 'everything that science can suggest for the improvement and perfection of cleaning'. The firm employed between thirty and forty people and the 'Steam Laundry', as it was known, became one of the largest laundries in Hampshire. In 1905, the laundry was extended to become the building that we can still see today. (A subsidiary, Workleen, started later in 1984, dealing with linen and garment rental for hotels, factories and schools. Their workforce has numbered up to fifty people, half of which work on the production side, and half on customer service.)

Founded in 1919 by the brothers Arnold & Moss Levy in Sandringham Road on the site of a former power station and laundry, the I.T.S. Rubber Co. was to become the largest employer in Petersfield, with 250 employees at its peak. The company benefited from its own loading bay on the sidings of the Midhurst branch railway line for its freight wagons.

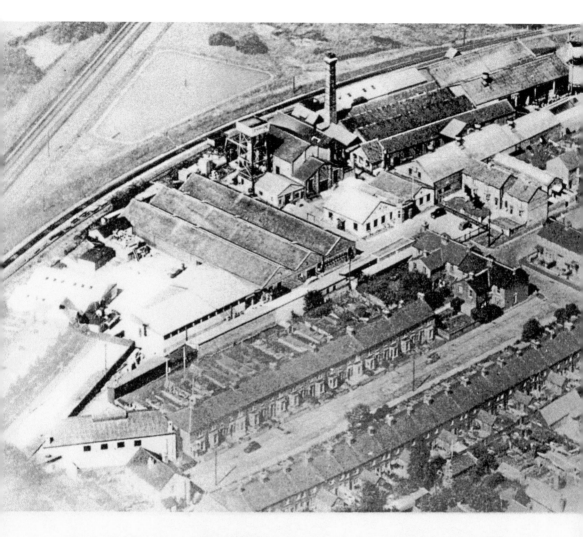

Aerial photograph of I.T.S. Rubber Limited factory, manufacturing rubber soles, heels and Minibrix famous interlocking building toy.

I.T.S. Rubber Limited
58 Years On

The I. T. S. Rubber Co. (later Itshide).

The Itshide factory in Sandringham Road.

Arnold Levy's father had begun his working life in the 1890s in the 'leather and grindary' trade, acting as wholesale suppliers to the shoe repair industry. His business took him to America where he discovered a revolutionary new style of rubber shoe heels. The company name changed to Itshide in 1931 and the Petersfield factory was set up to manufacture the identical item under licence in the UK.

In 1927, a later subsidiary of the company, the Premo Rubber Co., began to produce model construction kits for children, consisting of interlocking hard rubber bricks called Minibrix to represent such buildings as Hampton Court, Tower Bridge, or the Empire State Building, as well as typical Tudor residences. Although production ceased during the Second World War, when the firm concentrated on products for the Ministry of Defence, it resumed after the war and survived until 1976 when its products were overtaken by the new age of plastic toys.

Itshide had been a useful source of local employment in Petersfield and won the respect and long-term loyalty of many of its staff, since it paid wages considered to be the best in town.

A third large company that ensured employment for local people from the 1920s, was South Eastern Farmers, established next to the railway station in 1923. It lasted until 1965, providing a wholesale dairy and milk processing depot, pasteurisation procedures and a distribution network for local dairy farmers. The company office, formerly a Temperance Hotel, was created in 1927 and also housed a laboratory; this building still exists in Station Road as 'The Old Dairy'.

At the rear of the offices were the milk storage tanks, added in the 1930s, which allowed for the seven-days-a-week supply and distribution of milk as far afield as London.

The proximity to the railway line allowed S. E. Farmers to have their own siding to allow direct delivery of their products to London, Portsmouth and Midhurst. At the peak of business

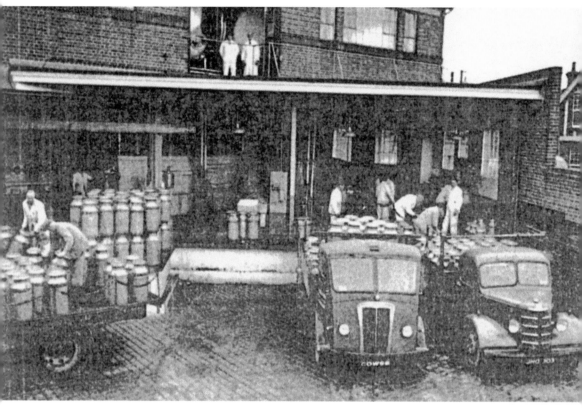

South Eastern Farmers' loading bay.

in the 1940s and early 1950s, some thirty lorries, each carrying between fifty and sixty churns, arrived here daily, having collected from local farms. The firm was eventually taken over by Unigate Dairies.

J. B. Corrie was another local firm to come to prominence in the town between the wars. First a partnership in the 1890s, then incorporated in 1925, Corrie's were able six years later to obtain a patent for fencing originally designed and developed in Argentina. They took over the Flextella Fencing firm in 1946 and are still trading today, with the fourth generation of the Corrie family now running the business. More than a quarter of Petersfield employees have been with the company for over twenty-five years.

Brewing was still one of Petersfield's chief industries prior to the Second World War, the largest breweries being Amey's, Luker's and the Square Brewery. Two nearby villages specialised in hop-growing: Col. Bonham-Carter was well established at Buriton, as was Charles Seward at Weston.

The Amey's Borough Brewery had begun trading in around 1880, employing thirty-three men and boys, but was not registered as a limited company, Amey's Brewery Ltd., until 1941. The founder, Thomas Amey, had been a dairy farmer, but he gradually moved into the more stable and profitable business of brewing. At the Borough site in Frenchmans Road, he boasted his own private siding, which allowed barley and other supplies to be delivered directly by rail. On his death in 1896, the brewing business was continued by his daughter Elizabeth, who eventually extended their franchise to twenty pubs, both local and farther afield, thus providing many employment opportunities to Petersfielders, especially at the height of their

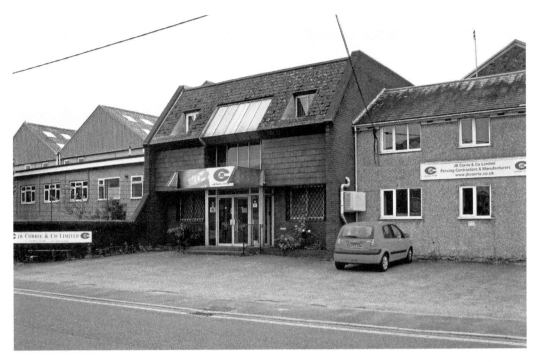

Above: Corrie's fencing manufacturers, Frenchmans Road.

Right: Corrie's: welding in the factory.

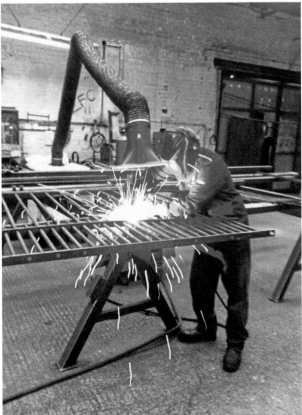

Ameys' Borough brewery, 1925. (Courtesy of Bill Gosney)

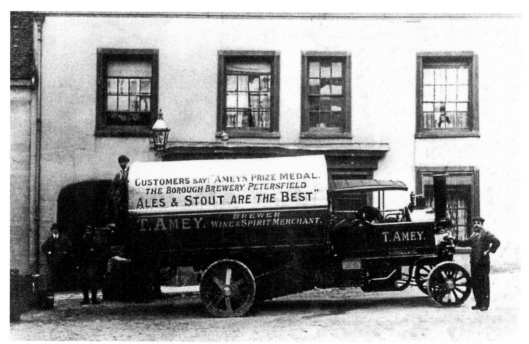

Ameys' steam waggon.

success in the interwar period, when they employed up to forty staff. However, by the end of the Second World War, the company struggled to remain viable and, in 1951, it was sold to Whitbread's. The brewery yard, now known as Amey's Estate, consisted of stables, fodder store, engine shed, bottle-washing department, brewing house, coopers' shop, and a bottle and spirit store. When the company ceased trading as a brewery in the late 1940s, the site became the small business and industrial estate which it remains today. It currently houses a mixture of eighteen units of varying sizes, with the bathroom firm of LittleJohn on the centre site in the original brewery building. Today, up to fifty staff work in the whole estate, which is appreciated for its proximity to the centre of town and adaptable to the needs of both large and small companies.

Luker's Brewery in College Street continued to be a major local employer until the early 1930s. They had acquired the four old Antrobus almshouses adjacent to their brewery tower and used them as a boiler house and store in the late nineteenth century. In keeping with the conventional Victorian ethos of family businesses, their employees enjoyed the support and friendship of their bosses' families who looked after their welfare and happiness. However, when both the Luker brothers realised, for want of a family successor, that they would have to sell their Petersfield business, they insisted that the workforce be taken on by the Strong's brewery group of Romsey. The College Street buildings remained empty for three years. Tragically, in the summer of 1934, the whole premises, including the tower, caught fire and had to be demolished. Petersfield had not only lost its major brewery and one of its key employers, but it also lost one of its best known landmarks, the brewery tower.

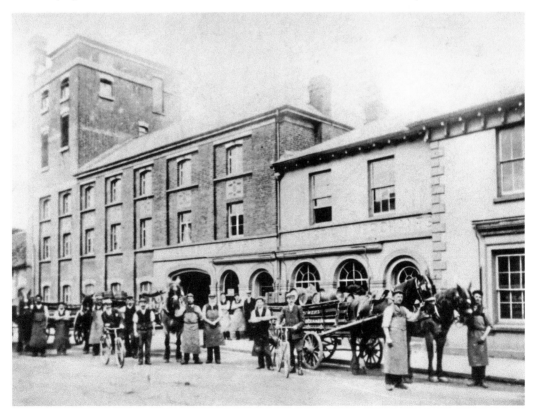

Lukers' brewery with their staff, 1907. (Petersfield Museum ref: PTFPM 2011.671)

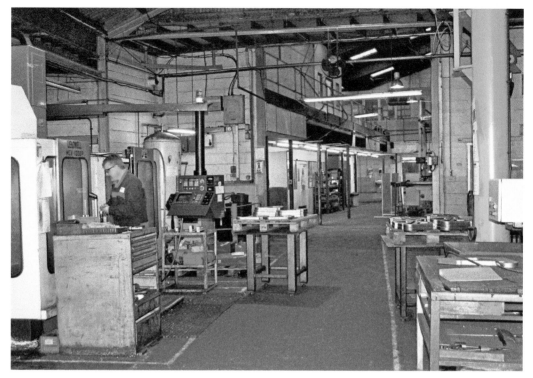

Tew's engineering today.

Technical and mechanical advances inevitably played their part in both revitalising a company's fortunes or in destroying it. Tew's, for example, had served the emerging businesses of motor car and motorcycle repairs at the turn of the century. As time passed, however, the firm became ever more specialised in the manufacture of engineering components and eventually gave birth to the new company, DCM. This natural progression from car and motorcycle repairs to light engineering began in the 1950s. Despite some serious setbacks in the following decade, Tew's re-emerged in 1971 with a stronger management and a move from No. 20 Lavant Street to No. 34 where it still operates today. By the end of the century Tew's became the largest private employer in the town, with over 100 staff.

Seward's, by contrast, suffered the fate of similar traction engine companies, whose skills were no longer in demand after the mid-1930s as farmers turned to petrol engines to power their threshing machines and lorries. They failed to adapt to new inventions in the field of engineering, and the skills – such as the use of the treadle lathe and electrical wiring – acquired by youngsters were obsolete. Horse-drawn ploughs disappeared in this period too, as tractors took over their role.

It was the Second World War that brought about the demise of the brickworks on the Causeway. What had been a source of employment for generations of Petersfield men who worked in the kilnyards and clampyards of Larcombe's and Nightingale's brickyards – digging the clay and milling it, making bricks and firing them, each turning out a thousand bricks a day – closed suddenly with the loss of its employees to the war effort. They were obliged to close their work anyway because the glow from the kilns lighted the night sky, making Petersfield a target for enemy bombers.

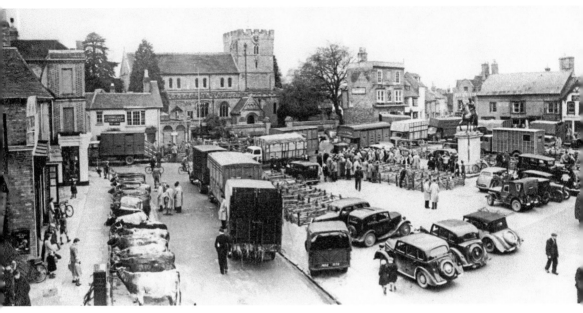

The Cattle Market in the 1950s.

In many ways the farming community still dominated Petersfield in the 1930s. First, small farms proliferated in and around the town, most of which have now disappeared completely: Herne, Buckmore, Lord's, Tilmore, Broadway, Penns, Weston, to name those situated closest to the centre of the town. The Wednesday cattle markets brought a whole population of farmers, drovers, buyers, stockmen and breeders to the very heart of Petersfield. Petersfielders depended to a large extent on the products of farming: there was the abattoir next to the Grange and several minor slaughterhouses adjacent to the town's butchers, all of which provided specialised employment; meat, milk and poultry products were brought fresh into the town to their numerous retail outlets, which everyone benefited from. In short, agricultural wealth generated general wealth. Much of Petersfield's historically indigenous professional expertise lay in the work of its agricultural workers who, together with the specialist carters, sheep-dippers and shearers, farriers, thatchers, pig rearers, charcoal-burners, hop-pickers and tellers, and horse workers, constituted a breadth of know-how probably unrivalled in the South Downs. Mechanisation brought an end to the old way of farming life: one machine took the place of a dozen men, and men with scythes gave way to the mechanical reaper towed by three horses.

For the long-term commercial future of Petersfield, however, a decision taken in 1936 was to leave its mark. In March of that year, a deputation of businessmen from Petersfield urged Southern Rail to arrange for fast London trains to stop at Petersfield station when the line was due to be electrified in 1937. This would attract professional businessmen to live in the area and, without regular stopping trains, it was feared that the town would be left off the map altogether. We can date the beginnings of commuter traffic to and from London from this time.

During the Second World War there was one factory that ran a clandestine operation, the Bell Hill Manufacturing Co., owned by Frank Jones. He'd had his own furniture design, manufacturing and retailing business in Southsea in the 1930s, but when his factory was demolished by an

incendiary bomb during the blitz on Portsmouth in January 1941, he began to look for new premises. He eventually found Ruttles builders yard in Petersfield, at the bottom of Bell Hill (now Nos 39, 41 and 43 Bell Hill), which consisted of a two-roomed office block and a row of wooden sheds. The original workforce from Portsmouth was supplemented by new recruits both from London and locally, totalling approximately fifty to sixty people employed by the newly formed Bell Hill Manufacturing Company. The most important – and most secretive – part of the operations was that concerning the all-wooden plane parts, which were produced at the factory. The initial contract was for Airspeed Oxfords, but this was followed by parts for Mosquitoes (the new twin-engine light bombers that started production in 1942) and tail sections for the Horsa gliders used in the D-Day landings of 1944.

During the war, Petersfield farmers obtained some help with their labouring work from three sources: a small number of conscientious objectors, an equally small number of Land Army girls, and, eventually, locally held Italian and German prisoners of war. What characterised Petersfield more than anything else from the early 1930s until the late 1950s, was the proliferation of long-standing family firms whose individual shops and offices filled the three main commercial streets of the town – the High Street, Chapel Street and Lavant Street. These developments supplemented the already well-established professional family firms working in the town at the start of the twentieth century: the two solicitors firms of Mackarness and Lunt, and Burley and Geach; the estate agents Jacobs and Hunt; the furnishing business of Rowlands, Son & Vincent; the jewellers Picketts & Pursers; and the removals firm of Reeves. All these firms are still operating in the town after a century of service to the Petersfield community and beyond.

At an Urban District Council meeting in January 1943, a question had been raised about post-war industrial development in the town, to which the Town Planning Committee had replied that the council were of the opinion that industries should not be established in Petersfield, the reason being that the natural beauty of the surroundings made the place especially suitable for residential purposes. The meeting concluded with the generally accepted feeling that some light industry could be acceptable, indeed beneficial, to the town, but that the question of zoning it in suitable areas was all-important.

The immediate post-war need for employment opportunities to benefit those men returning from the war was felt, of course, in the housebuilding industry. In the town, there were still some eighty German POWs, and these men were temporarily employed on the UDC's housing schemes to help with the building of streets and sewers. They – along with nearly half a million others who had been similarly detained in Britain after the war had ended – were eventually repatriated to Germany after spending ten months working in Petersfield. The population of the town recorded at the 1951 census (6,616) had also risen rapidly, by 22 per cent, since 1931.

The Portsea Island Co-operative Society announced in 1953 that it would be rebuilding and expanding its store in the Square. The new shop would provide the town's fifteen-year-old school leavers with the chance of a job. The more jobs available in shop work, the better the prospects of advancement in the retail trade, and the less likely the need for youngsters to take uncongenial jobs in factories. As a result, there appears to have been virtually no unemployment in Petersfield at this time.

It was clear that the nature of trade itself in Petersfield was changing: as moves towards a light-industrial base for the town progressed, so the old farming community sensed its decline. Many factors contributed to this phenomenon: the introduction of new industry, the lure of urban life, low agricultural wages, poor public transport in rural areas and poor accommodation for farm workers.

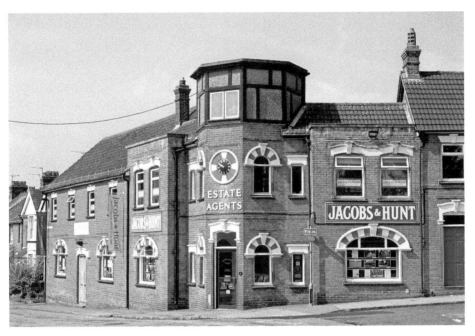

Jacobs & Hunt, estate agents.

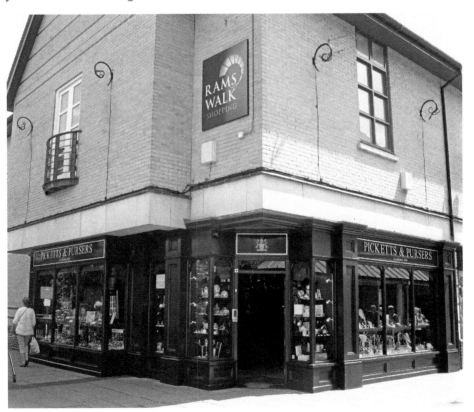

Picketts & Pursers, jewellers.

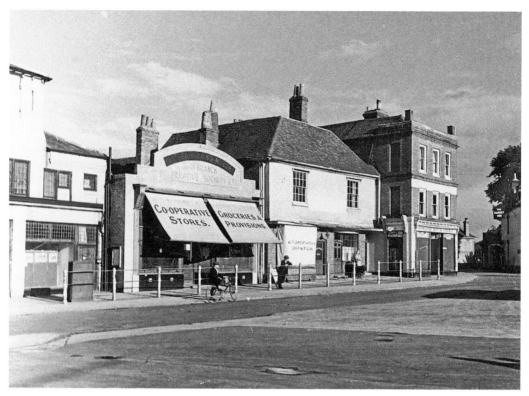

Co-operative Stores, 1950s.

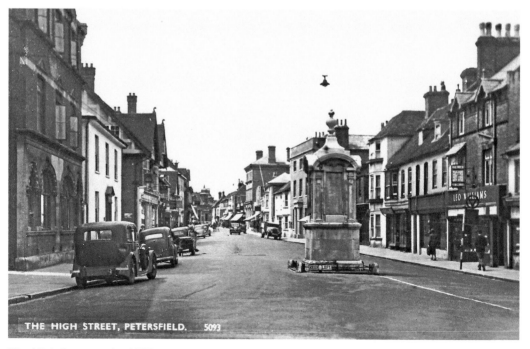

The High Street in the 1950s.

Greater mechanisation once again played a large role in the changing pattern of agricultural life. At Weston Farm, for example, the introduction of new machinery displaced around thirty people whose families had worked for generations in bringing in the harvests and brought an era of family orientated and community-conscious work to an end. It was this sense of community that was being slowly, and often brutally, lost in the agricultural sphere, just as it was to affect the commercial sphere in the years to come.

Indirectly linked to the diminishing agricultural scene was the fate of the Taro Fair. The first Heath Fair had taken place in 1820, when it was advertised 'for the shew of cattle' – there were 1,400 animals present, half of which were sold. During the twentieth century, however, the cattle fair slowly dwindled and during the First World War the best horses had been taken away for the war effort. Since the Second World War, the number of horses for sale had been dropping year by year, and the sale of horses ceased after 1953.

Another major issue that overwhelmingly dominated the discussions of the first years of the 1960s was that of Petersfield's cattle market. Part of the problem for the market had been the government's wartime takeover of all cattle, sheep and pigs sent for slaughter, which had upset the process of the direct and private exchange of animals between farmers and auctioneers or between dealers and slaughterhouses. The fate of Petersfield's cattle market was sealed in 1962, when the Chamber of Commerce decided that it would take no further action to prevent the threatened closure. After many years of slow decline, and following a particularly harsh winter in 1962–63, the last market was held in the Square in May 1963.

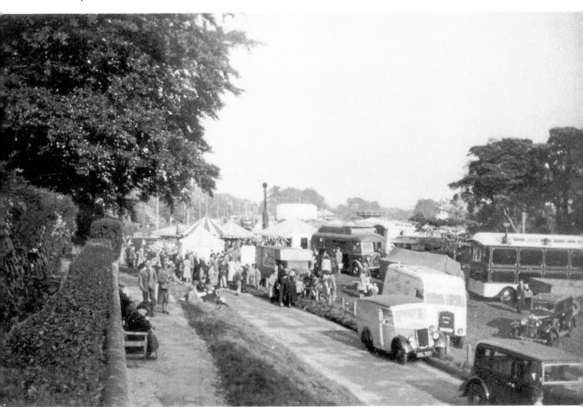

The Heath Fair in 1951.

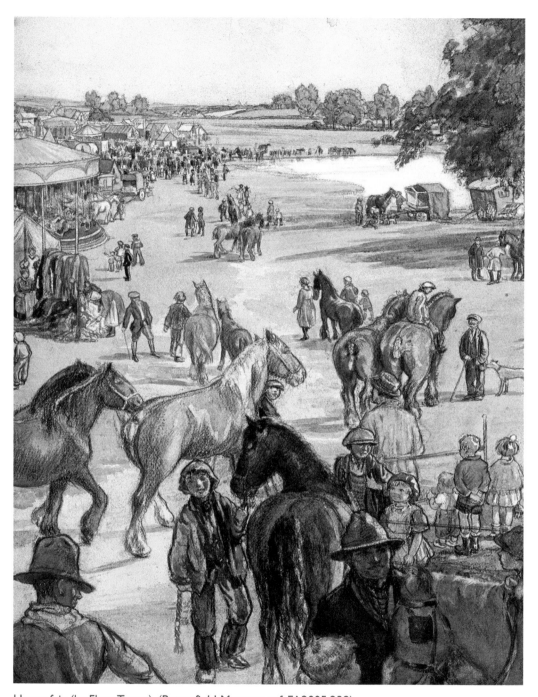

Horse fair (by Flora Twort). (Petersfield Museum ref: FA2005.239)

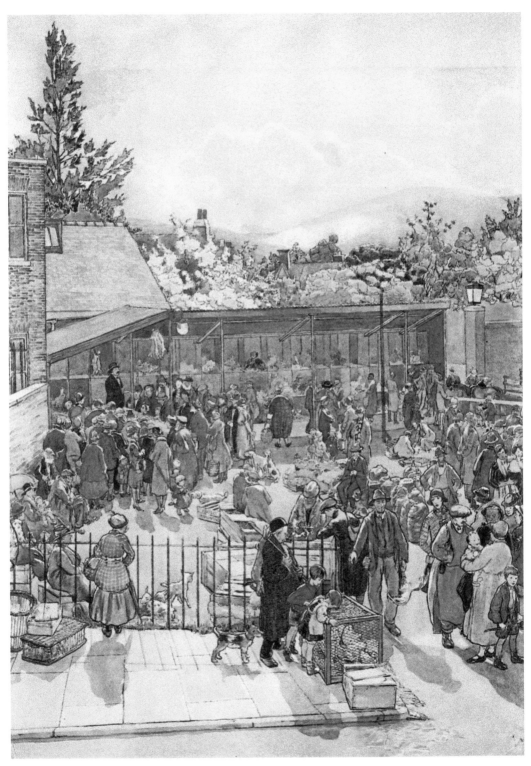

Poultry market (by Flora Twort). (Petersfield Museum ref: FA1985.3.30)

The poultry market (now the site of Waterlooville Carpets) ran for a couple of years after the cattle had departed. It sold fruit and vegetables (often the surplus production from people's gardens) as well as hens, chicks (in boxes), cockerels, rabbits, turkeys and geese (at Christmas) and was a natural attraction for young children in the town. As with the cattle market, however, new regulations brought in to deal with outbreaks of foot-and-mouth disease (and, in the rabbit population, myxomatosis) had an impact on the numbers of animals for sale, and this rendered the business unviable.

Several problems confronted Petersfield jobseekers in the mid-1960s: the small number of jobs available within the town itself, the lack of apprenticeships for school leavers, and the shortage of cheaper housing in the town which added to firms' struggles in finding labour. However, these negatives were offset by the announcement that a new £180,000 poultry-packing station was to be sited at Penns Farm; a new factory for Calibrated Papers Ltd was completed in Swan Street in 1961 (now the site of Drum Mead); and 2.25 acres of land in Frenchmans Road were awarded to Raglan Facilities Ltd for light industrial purposes.

Far-sighted councillors were still calling for one single site to be identified as suitable for an industrial estate, but others preferred to adopt the piecemeal approach of offering smaller individual plots, fearing that a specific area designated as an estate would alter the town's character too much. It was Raglan Developments Ltd that was without a doubt to bring the most radical change to the physical appearance of Petersfield between 1960 and 1965. It was directly responsible for the removal of several historic buildings in the High Street: the Dolphin Hotel, the Victorian post office and the seventeenth-century private house, Clare Cross. By 1968, Raglan owned two supermarket sites, nine shops, twenty-six flats and twenty lock-up garages in the town.

Unfortunately, by 1964, Calibrated Papers had found it uneconomic to operate in conjunction with its sister factory in Park Royal, London, and it announced its closure. It had employed eighty staff in one of the most up-to-date industrial buildings in the country, and this demise indicated that another white elephant was about to be born.

In January 1965, industry-starved Petersfield was promised four new factory units in Frenchmans Road on a site originally owned by Raglan, each with an industrial floor area of less than 5,000 square feet, thereby avoiding the need for an industrial development certificate. The result was the 1960s-style 'factory in a garden' complex named Paris House.

At the Itshide Rubber factory in Sandringham Road, an £80,000 five-year development and expansion programme was set to quadruple its capacity of rubber products, proof that the industry was responding well to the incursion of plastic products in recent years. Items coming off the production line included rubber seals and car shock absorbers, as well as their traditional output of soles and heels for both domestic and overseas markets. The factory was the largest manufacturer in Petersfield, with a labour force of over 300 employees.

Regrettably, jobs were about to be lost at the South Eastern Farmers' depot, which closed in 1965; for the fifty employees, the news came out of the blue. The government's reorganisation of the Milk Marketing Board for the allocation of milk supplies had hit the depot hard. With its demise, another link with Petersfield's rural past had been severed.

With hindsight, Petersfield's steady, even hesitant, growth, not only in terms of its light industrial base, but also in terms of its population, its physical development and its civic progress, must surely be considered to have been an asset compared with, for example, the inordinate industrial growth of Basingstoke or the demographic surge south of Butser.

It could be argued that Petersfield had deliberately fostered the image of a high-class residential area where large-scale industrial development was discouraged. Although this view

Calibrated Papers in Swan Street.

Raglan's destruction in 1964–65.

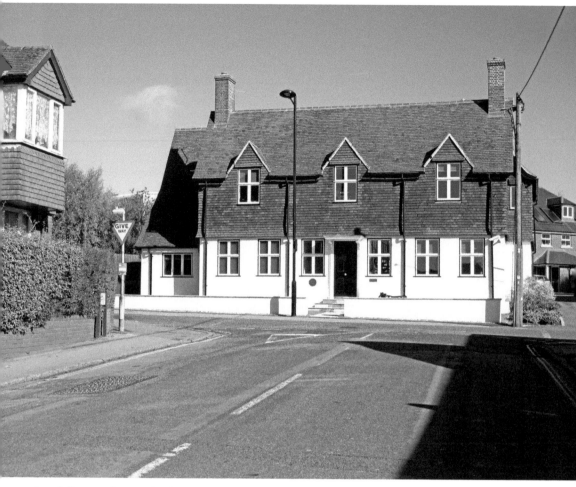

South Eastern Farmers' offices today (The Old Dairy).

smacks of social engineering on the part of councils and councillors, there is probably an element of truth in it.

Light manufacturing in Petersfield accounted for around 2,000 employees in the mid-1960s, with an impressive and comprehensive array of skills. The draft Town Map was about to be published and it would show additional sites that would be made available to companies wishing to establish themselves in the area. One good example of this new approach to attract light, skilled industry into Petersfield was the arrival from London, in March 1967, of the organ builders Henry Willis & Sons Ltd. This established old firm, founded in 1845, and which had made organs for many cathedrals – including those at Westminster, Canterbury and St Paul's, and in the Royal Albert Hall – had offices in Southampton and London that it wished to amalgamate. It therefore no doubt seemed logical to set up in Petersfield, which, it said, it had chosen for its 'old world charm'. It erected a workshop with offices and stores in Rushes Road. It survived until 2005, when it relocated to Merseyside and thirteen homes were built on the site.

By the time of the reorganisation of local government in 1974 – when the East Hampshire District Council (EHDC) replaced the Urban District Council – the scene was set for a

Kebbell's Herne Farm estate sign.

population expansion, and hints of it came in 1971 with the first intimations of a massive estate to be built on the Herne Farm site. Permission for this was granted at the beginning of 1972 and a developer, Kebbell Development Ltd, received planning consent for the whole area, which would eventually contain over 800 houses.

The name Penns Farm was altered to Penns Place in 1970 when the farm buildings and around 70 acres of land were bought by the Lifeguard Insurance Co., who built offices there. They were to grow rapidly to become one of Petersfield's major employers, but, sadly, underwent an equally sudden collapse a few years later with the loss of forty-two jobs. In 1976 the land was acquired by the EHDC, who took on around 200 staff there.

The Estee Lauder International Group came to Petersfield in 1970 and moved, with nearly 400 staff, into Paris House in Frenchmans Road in 1972. In 1977, they sought to enlarge their operation by submitting proposals to replace their premises with a large new plant nearby. Whitman Laboratories Ltd, part of the Estee Lauder International Group, wanted to consolidate and expand the multimillion-pound export trade of Petersfield's biggest commercial employer by building on 14 acres of farmland to the west of Princes Road. This would provide 100 more jobs in the general field of cosmetics manufacturing – perfume, fragrances, make-up and treatments. This was the Whitman development and it represented the initial phase of the whole Bedford Road industrial complex for Petersfield.

One particular retail transformation during this period is worthy of mention: the Folly Market building was built at the beginning of the twentieth century by Mr Victor Britnell, a

Estee Lauder in Frenchmans Road.

The Folly Market today.

solicitor, who had a yearning to run his own bicycle business. His wife considered 'trade' to be beneath her dignity, so he opened the cycle shop while she was away on holiday! From its beginnings as a shop, the building became Petersfield's first garage – his own two cars were the first in Petersfield – and the old showrooms and workshops are today's new Folly Market, which opened for business after its conversion in 1978.

The year 1985 was without doubt an important one for Petersfield with the closure of the Savoy cinema; the transformation of the somewhat Dickensian Itshide factory into a housing estate; the intense debate over the arrival of a supermarket in the Central car park; the opening of the public enquiry into a bypass for the town; the imminent demolition of the Railway Hotel; the green light for the new community hospital and the new-look Square. These massive transformations captured the attention and the imagination of residents as they watched the town develop on all fronts, industrial and commercial on the one hand, social and cultural on the other. On the downside, however, 600 jobs at the Itshide factory were suddenly at stake when the company announced that it would be pulling out of the town after several lean years of business.

With the bypass route now virtually confirmed by 1990, the proposal to create a new business park at the end of Bedford Road, filling a 13-acre greenfield site between the Whitman Laboratories and the new A3, was particularly welcome. This eventually became Vision Park. One major employer at the new site was Danish Bacon, a meat warehouse, which in 1993 offered 170 jobs in packaging and distribution. The site is now occupied by a logistics firm.

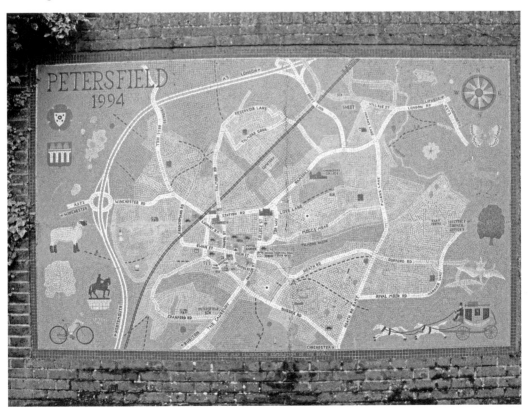

Commemorative mosaic in Dragon Street.

Commercially, Petersfield was bucking the trend of a national recession in the early 1990s. Thanks to the new bypass and the imminent opening of the Rams Walk shopping mall, property companies were targeting the town with three schemes for a total of nearly 300 new homes and a new office block.

Light industry was also undergoing a renaissance in the town. Commercial property specialists Hall, Pain & Foster announced that they had 55,000 square feet of distribution and light industrial space changing hands in 1993, an indicator of the new accessibility and attraction of Petersfield to distribution companies, thanks to the bypass.

It was with a clear sense of a passing era that two neighbours on the east side of the Square also vanished at the start of the new millennium, both having traded there for nearly a century, both victims of social changes: the Co-op had been overtaken first by the supermarket revolution, then by the prosperity and changed shopping habits of the public, more and more of whom were turning to the Internet to shop; Rowland, Son & Vincent, another old Petersfield family firm, succumbed to the emerging café culture of the new millennium. Petersfield's commercial transformation from a reliance on its old local, family firms to a dependency on multiples was more or less complete by the end of the twentieth century.

The A3 Petersfield bypass.

Rams Walk shopping mall today.

PETERSFIELD TODAY

The past two decades have seen the continuing success of Petersfield's approach to its combination of ambience and attraction as an 'Ancient Market Town' and its sense of commercial nous, which has led to the development of a modern business ethos both within and on the outskirts of the town. The latest population figures show the town having close to 15,000 inhabitants. The recently published 'Petersfield Neighbourhood Plan' envisages a doubling of the industrial area over the next fifteen years.

The town today is home to a wide range of international companies and high-tech start-ups, mainly housed on the extensive Bedford Road sites, incorporating both industrial-scale units and smaller businesses in the Ridgeway Office Park and Rotherbrook Court. Their access to the A3 is vital to their transportation and communication networks, while Petersfield town, with its high-quality shopping facilities and attractive location, supplies every need to the several hundred workers who are employed there.

Whitman Laboratories, which has been in the town now for thirty-five years, remains the single largest employer in Petersfield, with almost 1,000 staff, the vast majority of whom are local people – accountants, microbiologists, mechanical and chemical engineers, logistics and distribution specialists, factory and production staff, quality technicians and team managers.

Medium-sized businesses located in the town include RAK Ceramics (at the original Estée Lauder site in Frenchmans Road), Agincourt Contractors (established in 1990), and Corrie's, all of whom have around fifty employees, while further development on the Buckmore Farm site will soon become available.

The decision to infill the area between the new bypass and the north-west corner of the town was both logical and laudable; it was a natural void and its development has promoted the town itself as a hub for business and light industry. The original farmland, owned by Peter Winscom of Stroud, had already been designated for commercial development by the local plan. It was mostly local firms who took up the first options on renting properties during Phase 1 of the estate in the 1980s.

Phase 2 was market-driven and has had a variety of different tenants for its larger units in the 1990s. The constructors, Kingston Estates, sold the units to an investment company, Newcombe Estates. Subsequent sales have been made both to buyers and investors. The design and accessibility of the Petersfield site has attracted great interest and the site is now very successful.

Ridgeway Park.

Rotherbrook Court.

Whitman Laboratories today.

Buckmore Farm.

Moneybarn.

Petersfield Business Park.

Commuters awaiting the 06.48 train to Waterloo.

Phase 3 consists of Vision Park, Mint House, Moneybarn, Rotherbrook Court and Ridgeway Park, predominantly let to small, local, commercial firms. Moneybarn is a large finance company with around 200 workers – not all local inhabitants. Its staff relations are excellent, providing free on-site gym facilities, bicycles for staff to ride into Petersfield, free drinks and fruit, with Petersfield firms providing a delivery service for snack lunches. It mostly takes on school-leavers.

The total working population of the business park is approximately 600. It does have its limitations (the high cost of local labour, for example), but with the Hindhead Tunnel, which opened in 2011, the M25 within easy reach, and the A3, the A272 and the railway on its doorstep, it is becoming recognised as a geographically and strategically ideal location.

Finally, the newest recruits to Petersfield's charm and convenience are the commuters who travel daily to London (or Guildford and Portsmouth) and who prefer the rural amenities (and the lower house prices) during their weekends. These new incomers ensure that Petersfield's central businesses – the shops, restaurants and pubs – continue to thrive and sustain the local economy. With the presence of this mobile community, the town has taken on a changed outlook and new confidence, a greater diversity in its business provision and, at the same time, an enhanced professionalism and, hopefully, a secure civic future.

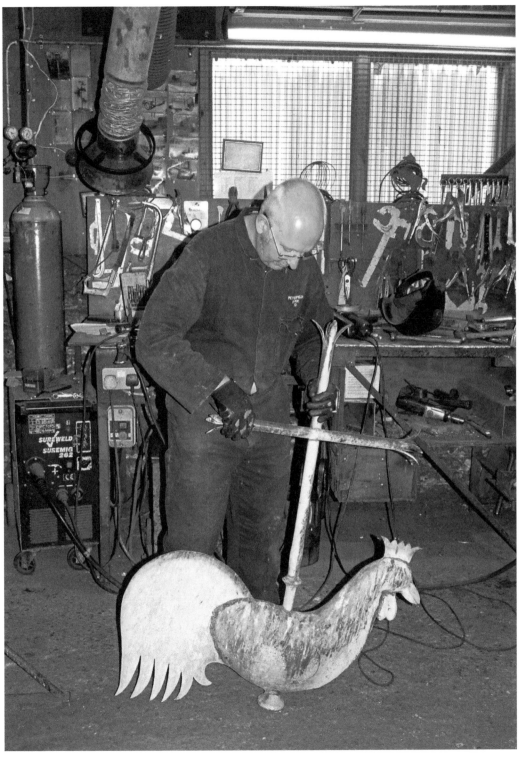

Petersfield Forge, Swan Street.

Above: The twice-weekly market in the Square.

Below: The High Street, looking west.

The monthy farmers' market.

ACKNOWLEDGEMENTS

ADDITIONAL MATERIAL

James Beggs, Wilf Burnham, R. K. Cardew, Gerald Davies, Alicia Denny, Jean Gard, Jennifer Goldsmith, Bill Gosney, Malcolm Hanson, Ken Hick, William Holder, Jeremy Holmes, Peter Jolly, Richard Jones, Roy Kersley, Tim Lambert, Eric Leaton, Marjorie Lunt, E. Arden Minty, Stuart Mitchell, Tom Muckley, Mary Piggott, Vivien Pike, Peter Price, Jean Prichard, Mary Ray, Nicholas Redman, Nick Swan, Jill Thompson-Lewis, Betty Wardle, Bob and David Weeks, Barclay Wills, and Sophie Yaniw.

PHOTOGRAPHS

Hampshire Record Office, Petersfield Museum, Butser Ancient Farm, David Allen, Teresa Murley, and Edward Roberts.

I would also like to thank my wife Irene and daughter Anna-Louise for their proofreading skills.

BIBLIOGRAPHY

Carpenter Turner, Barbara, *A History of Hampshire* (Phillimore, 1963).

Hick, Kenneth, *Petersfield, A History and Celebration* (Frith, 2005).

High Street, Petersfield (Petersfield Area Historical Society, 1984).

Jeffery, David, *Petersfield A Hundred Years Aago* (DWJ Publications, 2012).

Jeffery, David, *Petersfield at War* (The History Press, 2009).

Jeffery, David, *Postwar Petersfield* (Sutton Publishing, 2006).

'Parishes: Petersfield' in *A History of the County of Hampshire: Volume 3*, William Page (ed.), (London, 1908), pp. 111–121.

Street, Sean, *Petersfield, A Pictorial Past* (Ensign Publications, 1989).

The East Hampshire landscape, Countryside Commission Publications, 1991.

The Inns of Petersfield, PAHS, 1977.

The Market Square, Petersfield (PAHS, 2008).

Thomas, James H., *Petersfield Under the Later Stuarts* (PAHS, 1980).

Yates, E. M., *Petersfield in Tudor Times* (PAHS, 1979).

W. G. Hoskins, *The Making of the English Landscape* (Little Toller Books, 2013).

Also available from Amberley Publishing

DAVID JEFFERY

PETERSFIELD

THROUGH TIME

The No. 1 Best Selling Colour Local History Series

OVER
400,000
COPIES
SOLD

This fascinating selection of photographs traces some of the many ways
in which Petersfield has changed and developed over the last century.

978 1 4456 0857 0

Available to order direct 01453 847 800

www.amberley-books.com